Catalogue, Simon Fujiwara (2016)

		Chapter 1		Chapter 2		Chapter 3					
	目次	007	作品図版	153	テキスト		論考	182	鏡の中に見えるもの サイモン・フジワラが映し出す私たちの姿 野村しのぶ	186	フジワラの芸術的効果 クリストファー・グレイゼック
	Contents		Plates		Texts		Essays		Simon Fujiwara's Mirror on Us Shino Nomura		Fujiwara's Art Effect Christopher Glazek

190 幸福の経済学
ダニエル・フジワラ
Happy Economics
Daniel Fujiwara

Chapter 4
資料　196　作品リスト　200　展覧会歴
Appendix　　List of Works　　Exhibition History

Chapter 1 Plates

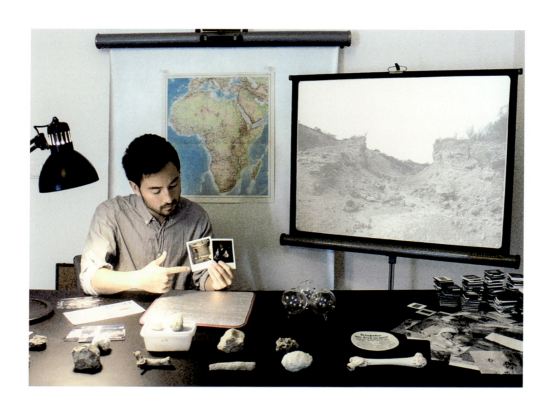

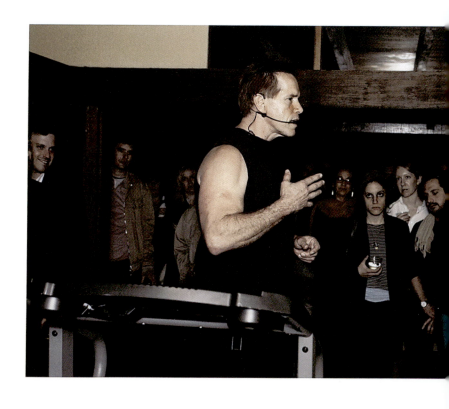

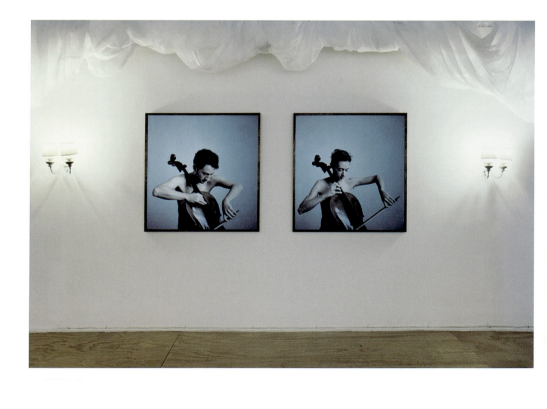

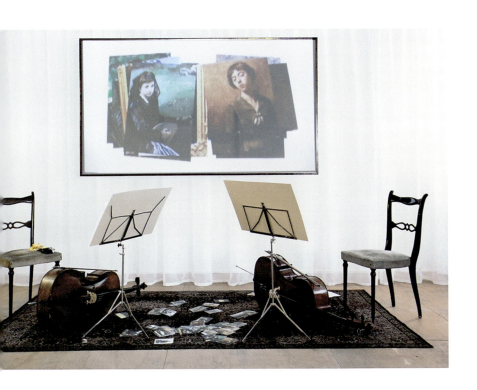

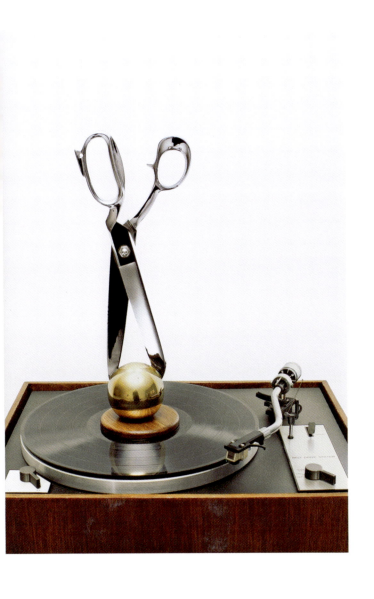

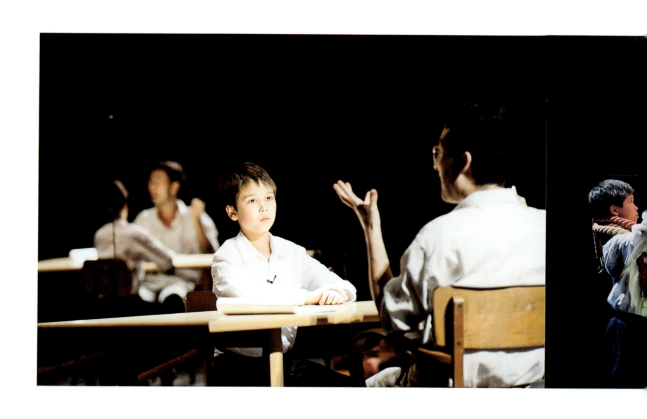

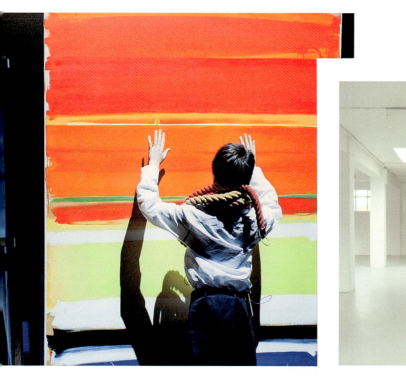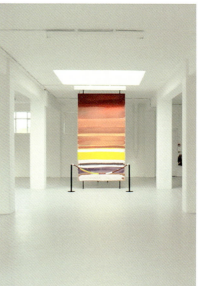

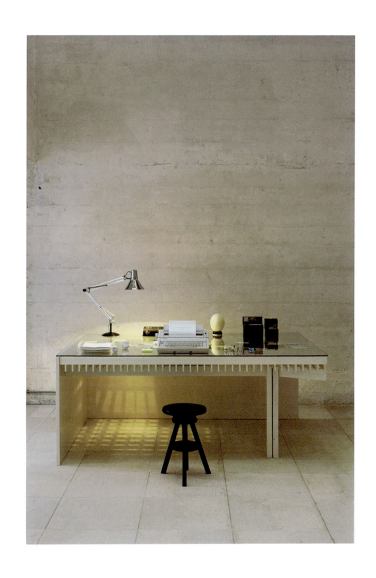

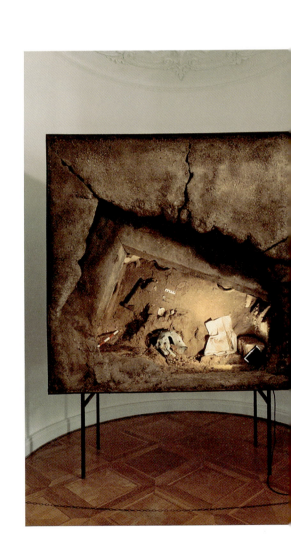

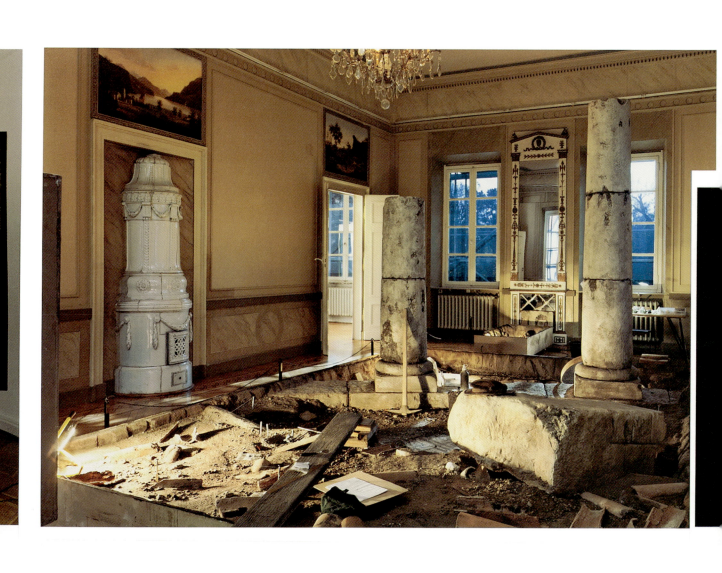

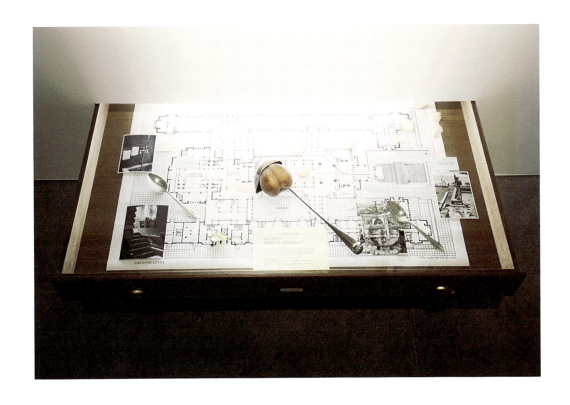

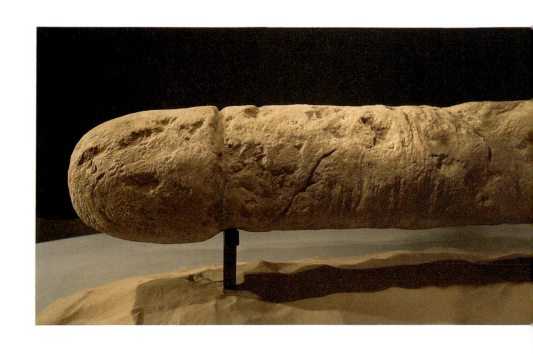

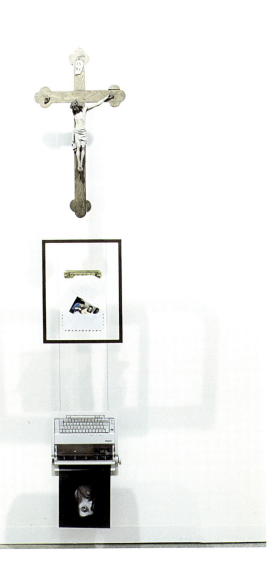

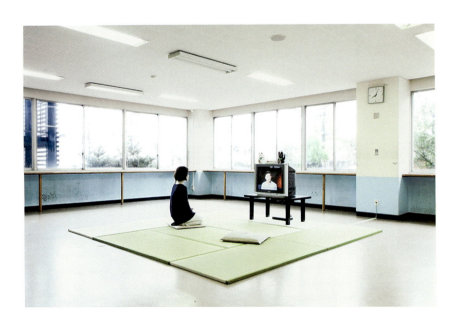

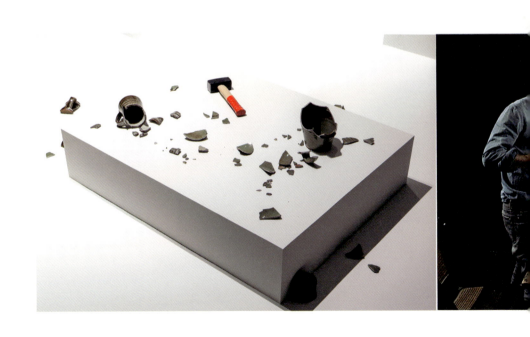

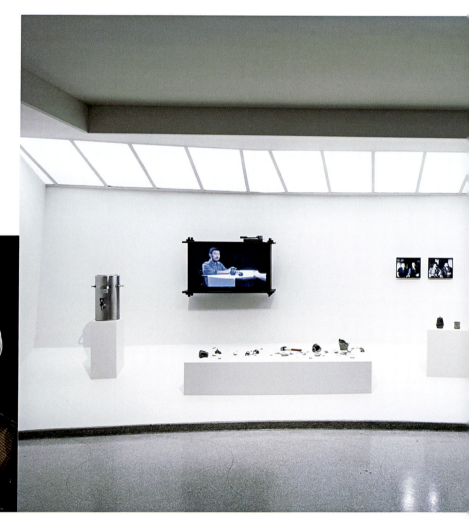

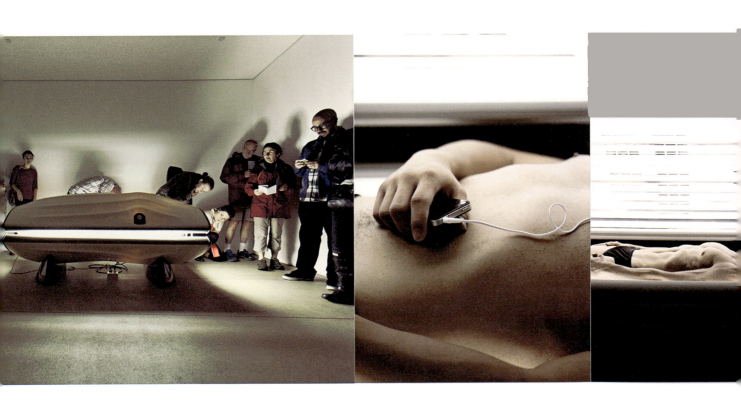

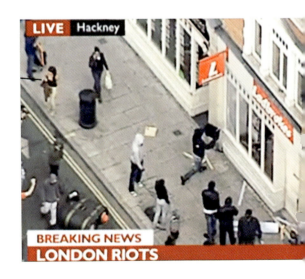

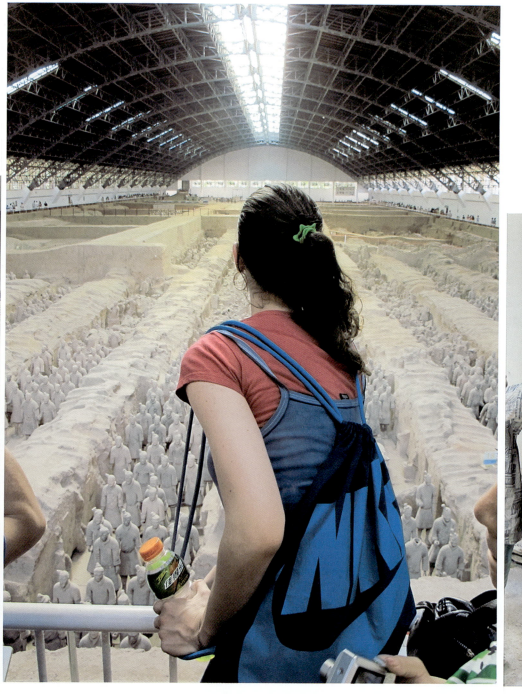

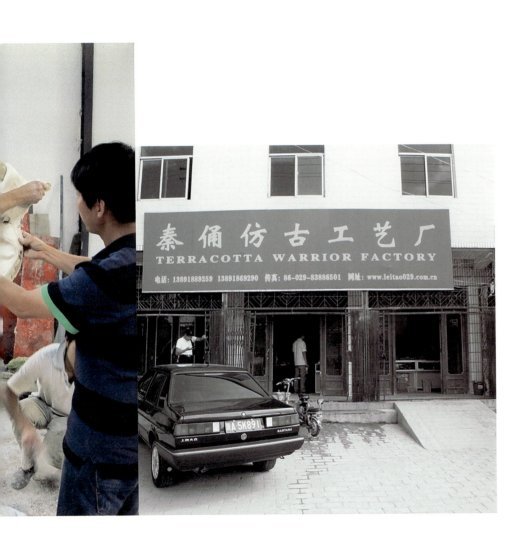

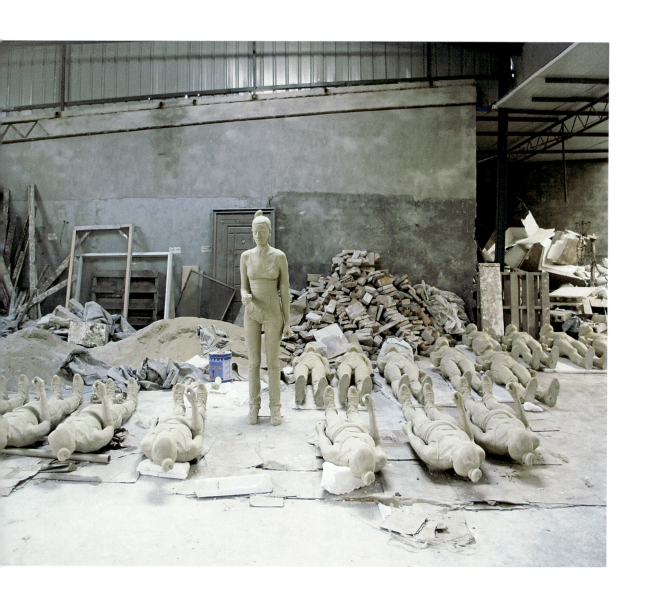

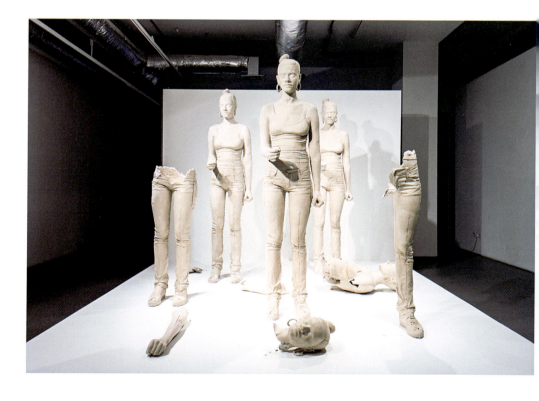

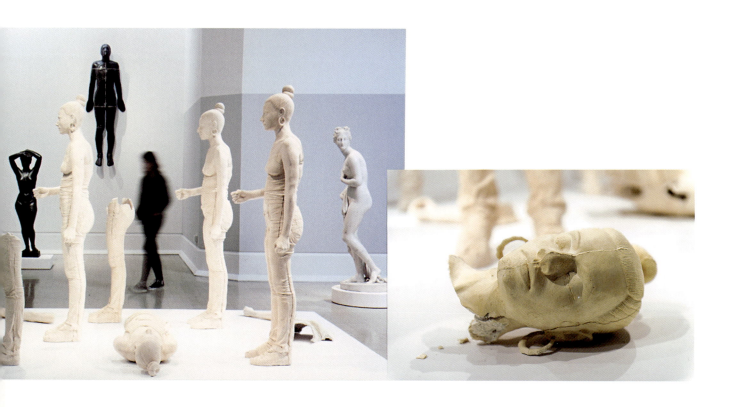

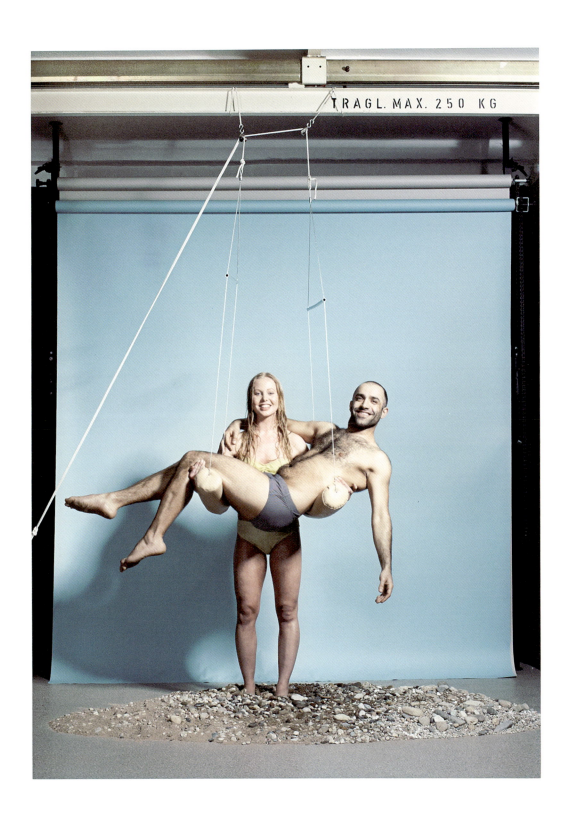

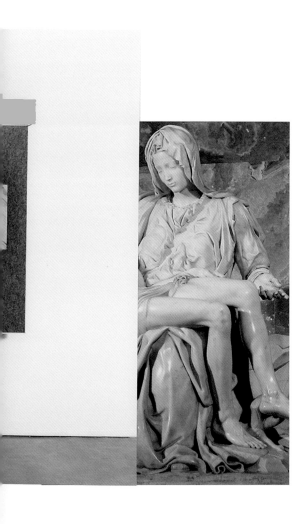

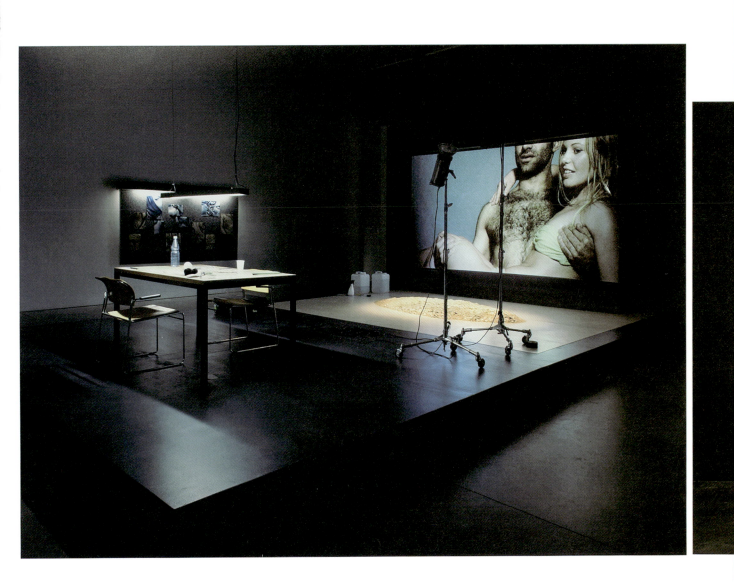

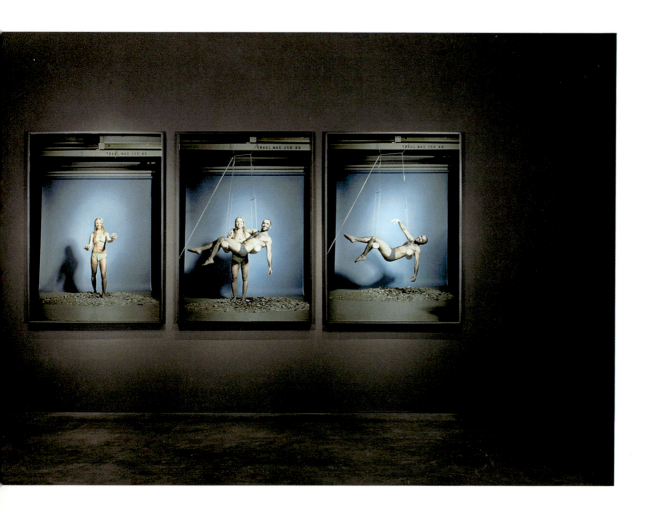

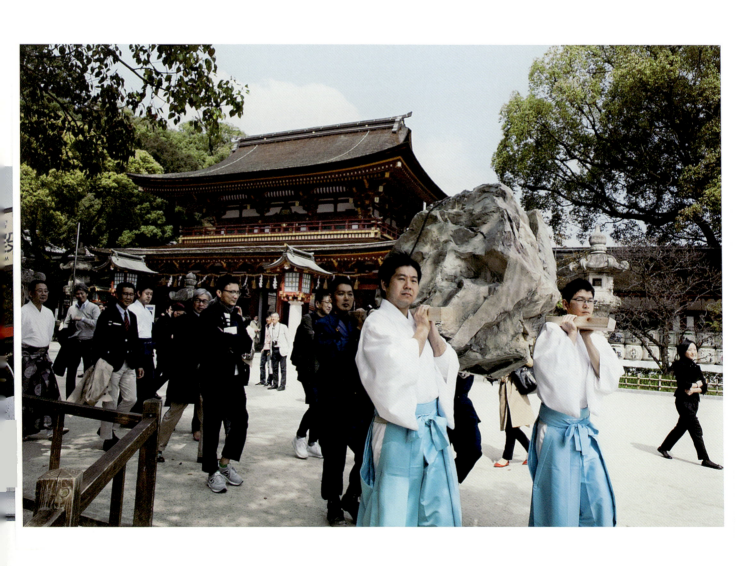

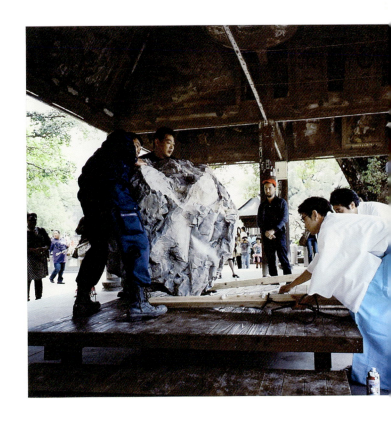

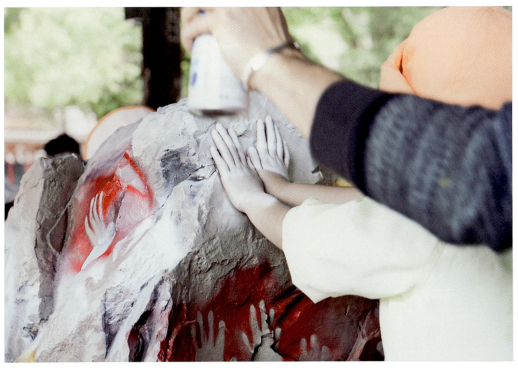

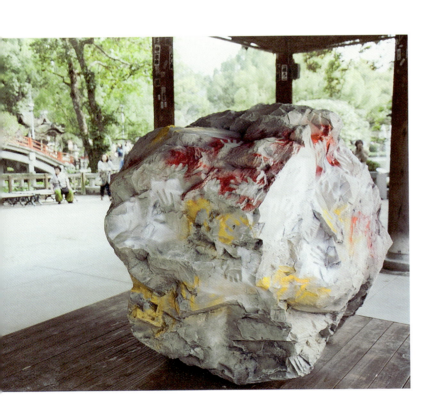

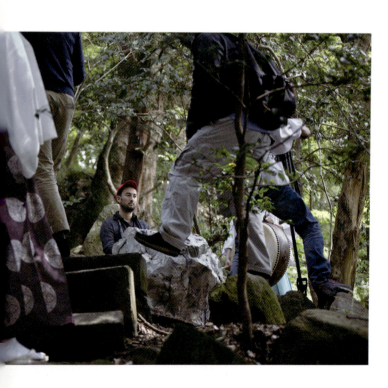

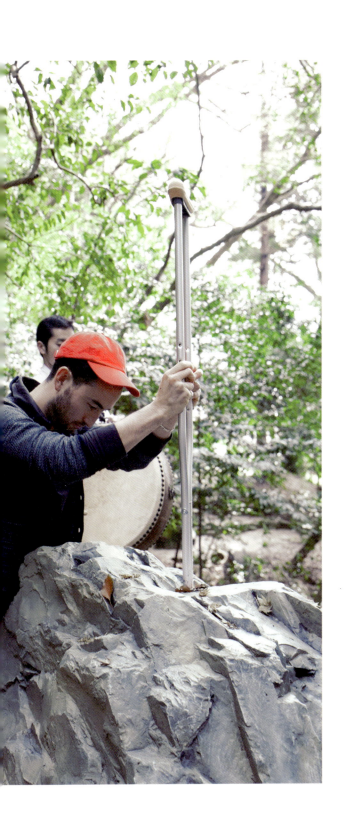

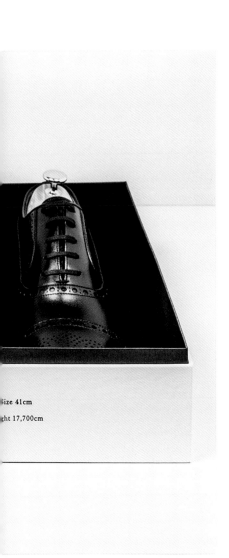

Size 41cm

ght 17,700cm

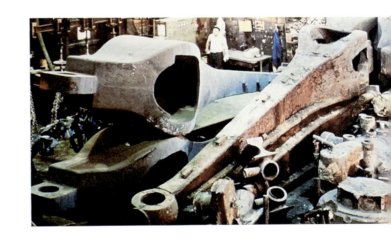

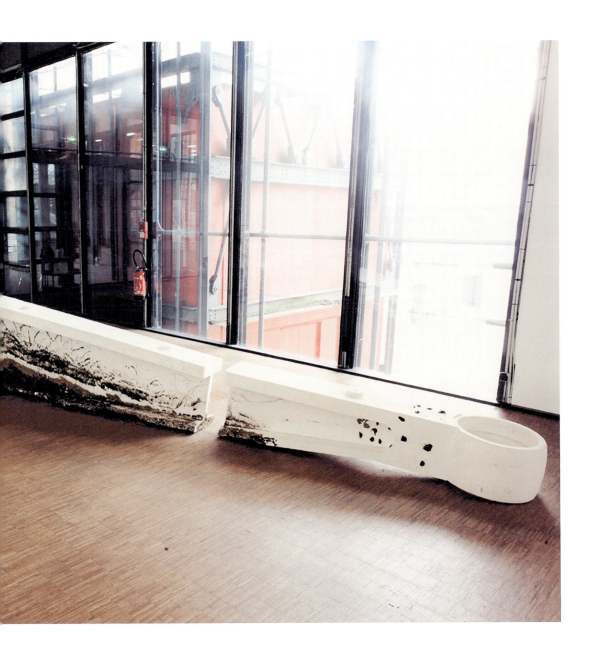

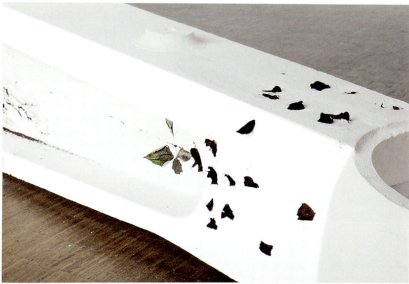

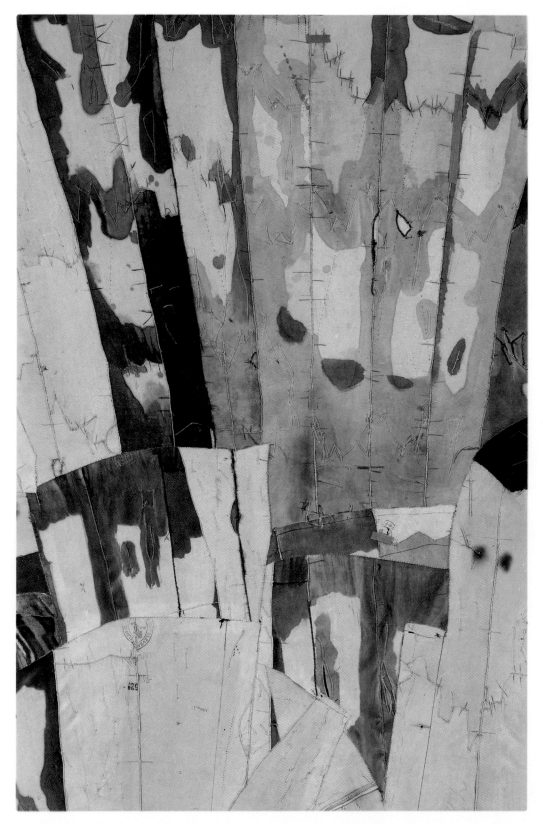

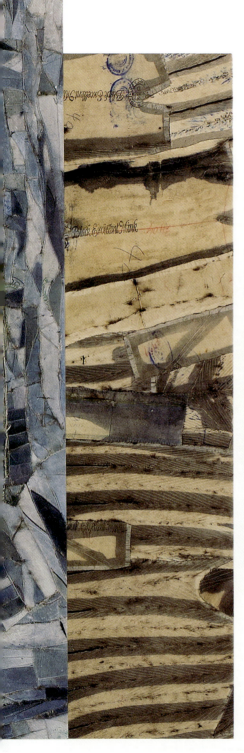

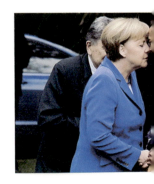

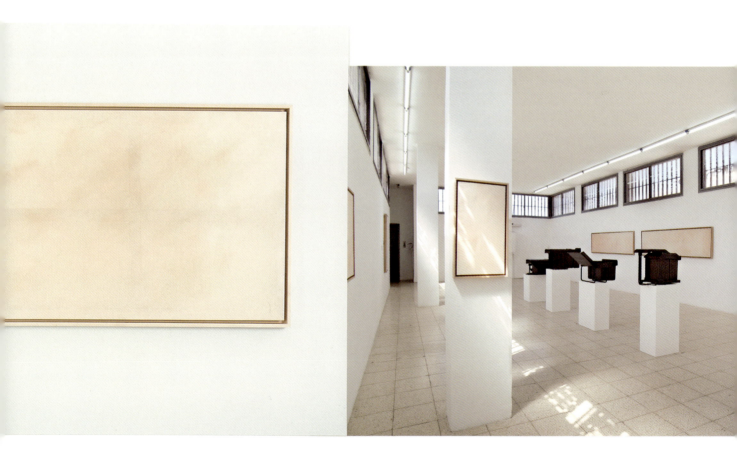

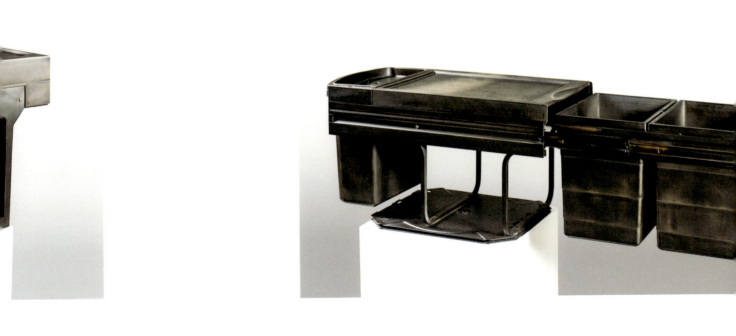

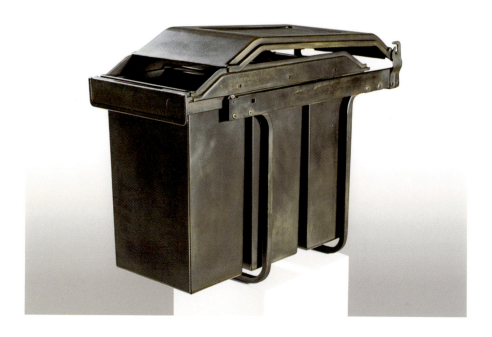

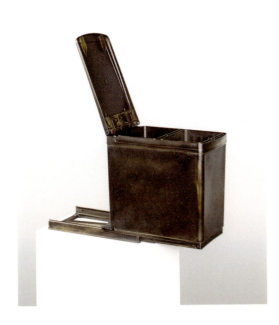

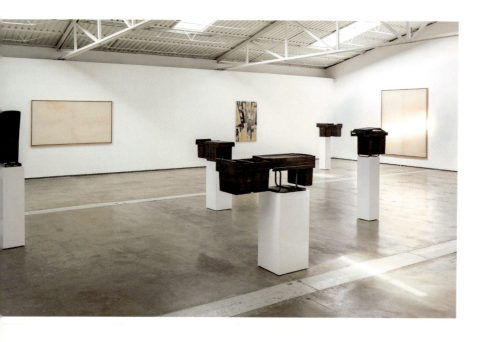

and I was born and raised on the trash site!

It became a dangerous place to live.

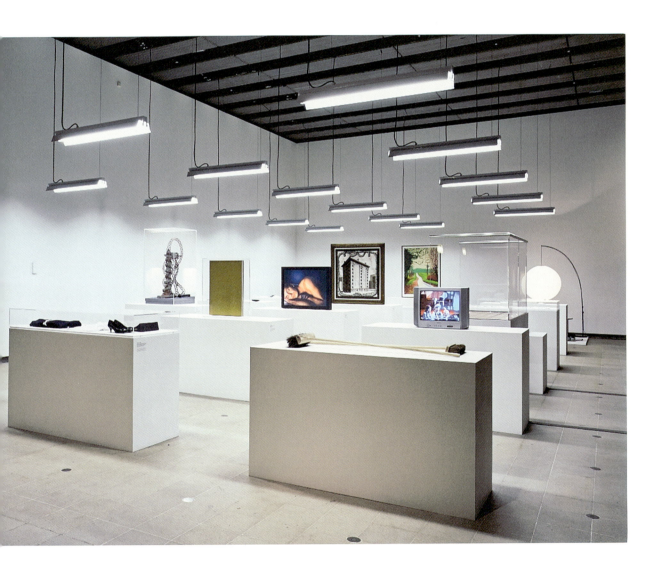

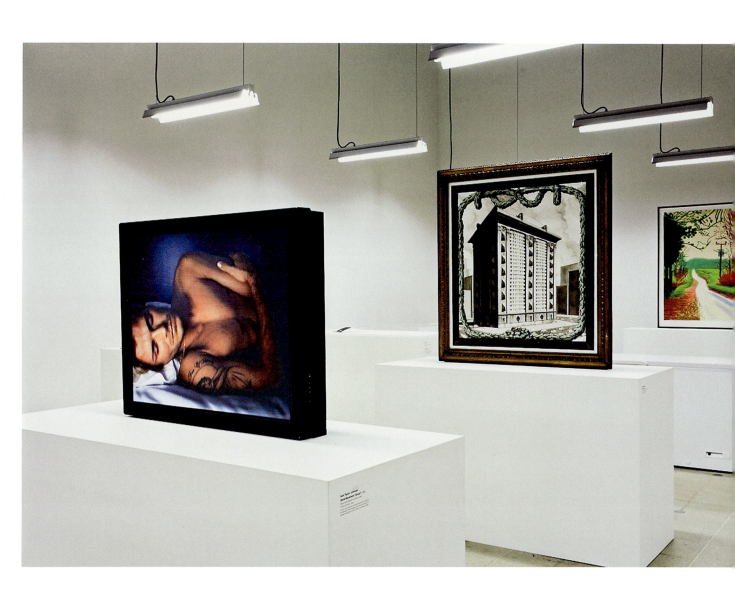

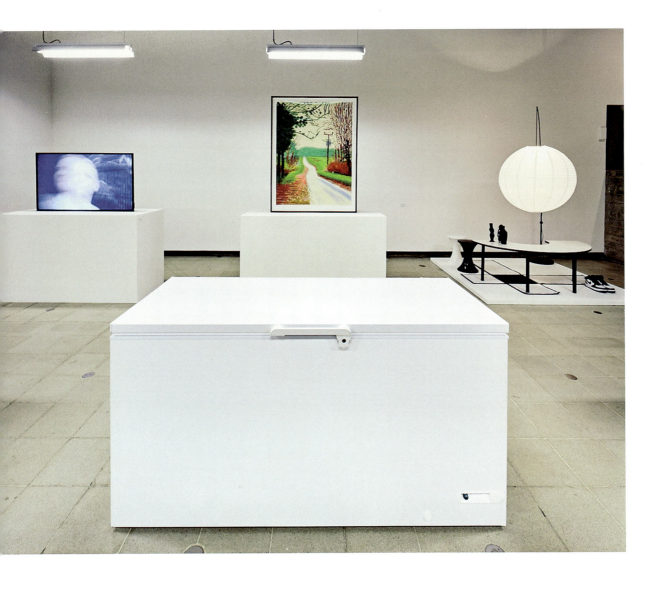

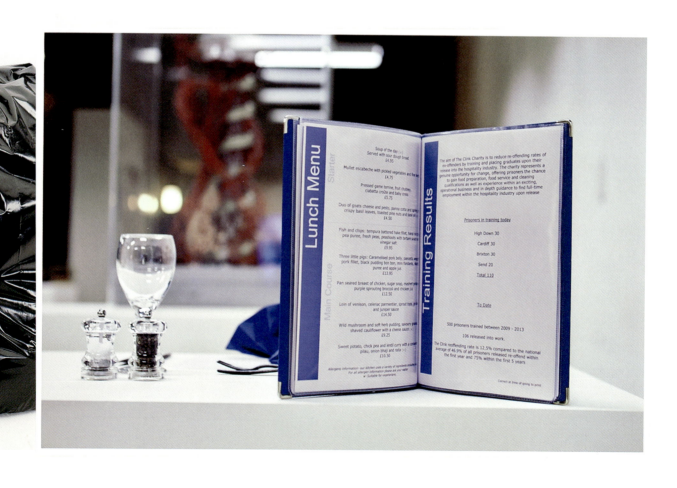

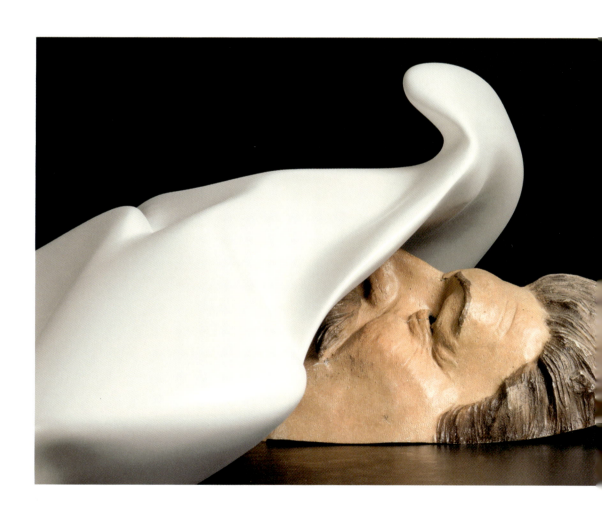

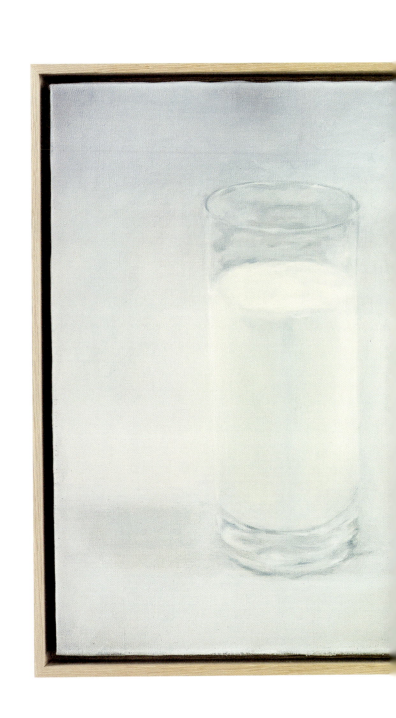

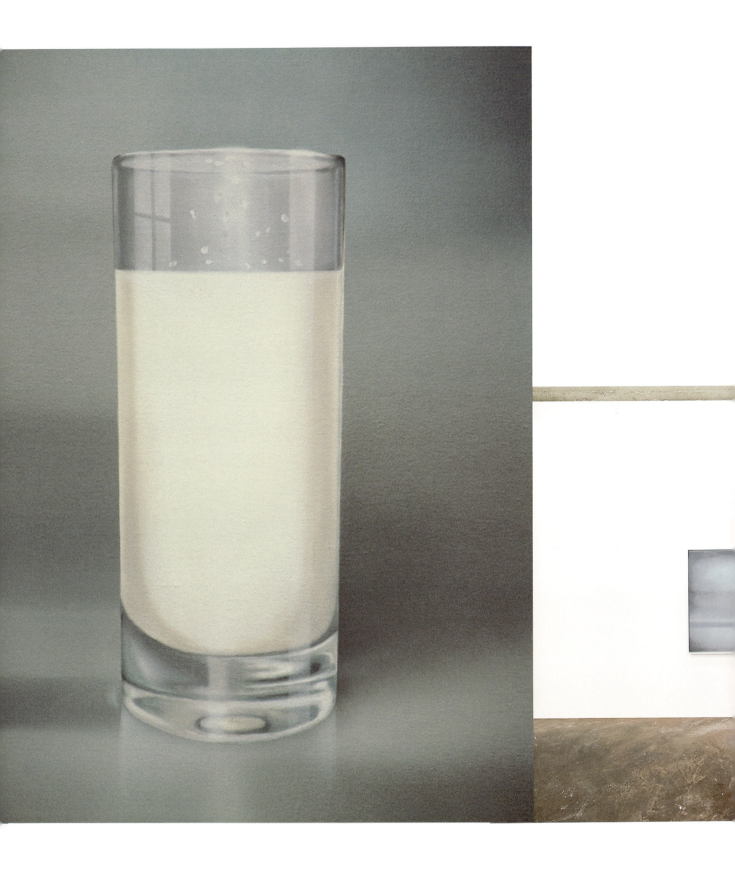

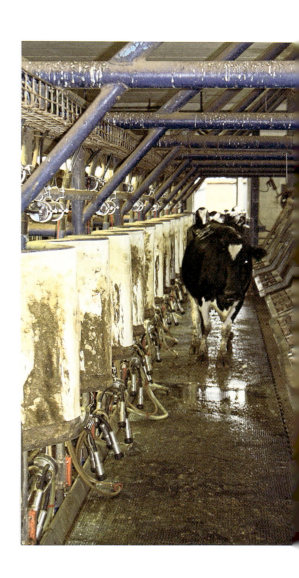

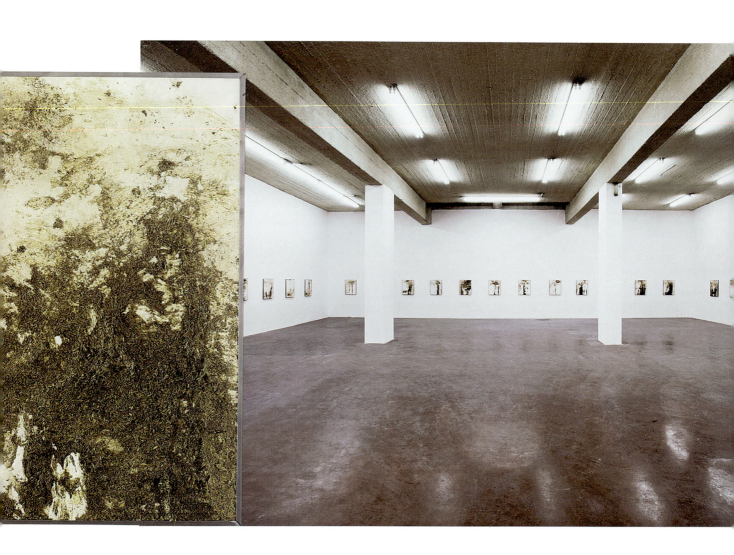

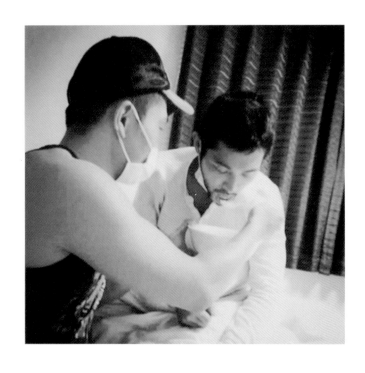

Chapter 2 Texts

ハッピー・バースデー
2008年
本、木製のスタンド、卵

p. 008

同じ9月10日生まれの人。
ローマ教皇ユリウス3世、ジョルジュ・バタイユ、ルドルフ・シンドラー。

近親相姦美術館
2008-2010年
パフォーマンス、スライドショー、インスタレーション、ヴィデオ

p. 010

父親が娘を愛すとは、娘が父親を愛すとは、未来にむかって伸びていく糸に結び目をつくるようなもの、流れの水が逆流しようとするようなものである。
シモーヌ・ド・ボーヴォワール

近親相姦美術館は、私がタンザニアのオルドヴァイ渓谷を旅した後に作った建築的要素の強い作品だ。最古のヒトが発掘されたオルドヴァイ渓谷は、人類発祥の地として知られている。考古学者のルイス・リーキーによって発掘された化石が「ホモ・ハビリス」または「ハンディマン（器用な人）」と名づけられたのは、さまざまな石器やフリント（燧石）とともに埋葬されていたためで、これらは二足歩行を行った最初の人類であることを示すとともに、人類が物質世界において他の動物をはじめとする周囲から優位性を持ち始めたことを物語る。フリントは殺害/解体の道具としても使われた。最古の武器であるフリントは、人類の始まりと終わりを結んでいる。とすると、世界を滅亡させるのは、産業生産や大量破壊を可能にする道具をおいて他にないということだろうか。

通常、生殖は生の存続を目的とされ、時は次の世代へ引き継がれることで進むものだが、近親相姦行為、特に親子間のそれでは、時間の流れはループし、逆流する。タンザニアのホモ・ハビリスの発掘現場を敷地として計画された架空の美術館である近親相姦美術館において、この遡行する時間の概念は館の問う哲学的問題の根底にある。

未来的でアイコニックな外形のこの美術館には、美術品や資料は収蔵されていない。というのも、文明は近親相姦を禁忌としたため、その事実を示す物理的な資料を残そうとしなかったからである。そのため当館は近親相姦の歴史を語るにあたって、物理的なものに頼らない方法をとっている。館内は、古代エジプトから現代までの時代を大きく3部に分けており、近親相姦にまつわる場所を再現したセットの中で、その歴史を伝えるパフォーマンスが毎日行われる。たとえばストラスブールの欧州人権裁判所のセットでは、ドイツの錠前士とその妹兼恋人であるストゥーブリンク兄妹（彼らの間には4人の子供がいる）をはじめ、近親相姦を裁く主だった裁判が演じられる。順路を進むと、旧約聖書の都市ソドムとゴモラの再現に出合う。いずれのセットもアフリカの泥建築の技法を用い、パフォーマンスを演じるのも地元民だ。これは、地元の経済と環境への配慮および貢献を旨とする近親相姦美術館の方針によるものだ。

気候上の観点から、美術館の建物の大部分は地下に造られ、アフリカの照りつける太陽から守られている。地下に位置するカフェは来館者の交流の場であると同時に、美術館にまつわるある逸話を示す重要な場であろう。南側の壁にあるのが、家族のなごやかな食事の場面を描いた壁画の複製である。元の壁画は、私の父が日本のとあるイタリア料理店のために描いたものだ。描かれた親子は日本人からイタリア人に人種が変えられているものの、父と当時4歳の私の姿である。それは建築家のこの美術館への署名であると同時に、人生における転換であった父子の帰還の象徴であるともいえよう。

インパーソネーター（そっくりさん）
2009年
パフォーマンス、インスタレーション

p. 012

ロサンゼルスのハリウッドにあるシンドラー・ハウス（シンドラー邸）でレジデンスをしていたとき、オーストリア出身の俳優/ボディビルダーであるアーノルド・シュワルツェネッガーが以前この歴史的建築を訪れ、建築家を目指そうとしたという逸話を知った。同じくオーストリア人のルドルフ・シンドラー（1887-1953）は、

保守的なヨーロッパに息苦しさを覚え、新しいライフスタイルとより良い生活の実験場としてカリフォルニアを目指した建築家だが、その存在はシュワルツェネッガーのキャリア形成の参考となったのかもしれない。シンドラー邸の息詰まるほど低い天井や薄暗い物入れはシュワルツェネッガーに故郷を思い出させた。結局、彼は政治家になった。

リンドール・グラントに私が出会ったのは彼が47歳のときで、サンセット大通りのホールフーズ・マーケットのジュース・スタンドでのことだった。彼が語るところによると、威圧的な軍人の父に連れられてアメリカ各地を転々とする子供時代を送った後、サンフランシスコに落ち着いた彼は、高層ビルの建設作業員として働き始め、そのうちに建築家を目指すようになった。アーノルド・シュワルツェネッガーとおそろしいほどそっくりな体型だった彼は、たまたま訪れたロサンゼルスで、タレント事務所にスカウトされた。当のシュワルツェネッガーはカリフォルニア州知事選のまっただ中で、グラントはすぐさま彼のインパーソネーター（そっくりさん）としてイベントやテレビ番組に引っ張りだことなった。シュワルツェネッガーが影響力を増すほどに、その鏡像としてのグラントの新しい仕事は増え、同時に建築の勉強は滞り、結局諦めざるを得なかった。そして彼は、本職のそっくりさんとなった。

2009年3月13日、リンドール・グラントはシンドラー・ハウスでパフォーマンスを行った。建築家シンドラーの仕事部屋に置かれた特製ランニングマシーンの上で「ウォーキング・ツアー」をするというこのパフォーマンスは、グラントが自分の半生とシンドラー、シュワルツェネッガーとの奇妙な相似を語るものだった。ランニングマシーンの速度は徐々にあがっていき、ついに疲れ果てて息絶え絶えになったところで彼の話は終わりを迎えた。

ホテル・ムンバーへようこそ　　　　　　　　　　　　　　　　　　　　　　　　　　　p. 013
2009年
パフォーマンス、インスタレーション

フランシスコ・フランコ政権下のスペインで、アリソンおよびカン・フジワラが経営していたホテル・ムンバーのバーを舞台とする同性愛的創作。

または

両親の人生を官能小説とした場合。

フェミニン・エンディング（女性終止）　　　　　　　　　　　　　　　　　　　　　　　p. 016
2009年
パフォーマンス、ヴィデオ、インスタレーション（ティモシー・デイヴィスとの共作）

　女性終止
　［名］行末に付された弱音節。詩、韻文、音楽の楽節など。

美大時代の学食で、ティモシー・デイヴィスと僕は子供時代にチェロを習っていたことを話していた。僕たちは同じ曲を弾いていて、同じくらい厳しく、エキセントリックで、強権的な女性教師についていたことを知った。なぜ僕らはあれほど彼女たちに惹かれたんだろう、と僕たちは考えた。なにが青春まっただ中のゲイの僕らを、女性的な形で低くて深い音色を持つこの楽器に引き寄せたのだろう、と。

最後のカストラート　　　　　　　　　　　　　　　　　　　　　　　　　　　　　　p. 019
2010年
レコードプレイヤー、金属の彫刻、レコード

思春期前の去勢は、性徴期の生理学的事象で通常は変化する喉頭の成長を抑制する。また、男子の性徴期に分泌されるテストステロンが不足することで、カストラートの四肢骨や肋骨の成長が通常より促進される。肋骨の長大化によって肺は大きなスペースを得るため、カストラートは少年期の繊細な声質と

強大な声量を同時に得ることができ、何世紀にもわたって熱烈に支持された。1870年に去勢は違法化されたが、同時期に発達した録音技術により最後のカストラートの演奏が録音され、これがカストラート唯一の録音音源となった。

ミラー・ステージ　　　　　　　　　　　　　　　　　　　　　　　　　　　　　　　　p. 020
2009–2013年
パフォーマンス、インスタレーション、ヴィデオ

パトリック・ヘロンの《水平のストライプの絵画：1957年11月—1958年1月》は、僕が初めて出合った現代美術作品で、僕をゲイにした。テート・セントアイヴスの開館記念展でのことで、当時僕は11歳だった。豊かな色使いと白い油絵具の滴りに導かれて、僕の中で急激な変化が起こっているのを感じた。これがなにを意味するのか、何年も経ってからこの経験を演劇の脚本にしようと思うまで、考えたことはなかった。結局上演されることはなかったが、この劇の主題は抽象絵画が思春期の少年に性的な目覚めを起こさせたことを記すことの不可能さだった。「〈わたし〉の機能を形成するものとしての鏡像段階——精神分析の経験がわれわれに示すもの——」の中ででラカンは、鏡は子供の自己確立の手段として機能し、思春期においては性的なアイデンティティを自覚させる、と述べている。生まれて初めて観た抽象絵画は、そこに具象性や性差を示すものがなかったからこそ、しまいこんでいた思春期の僕の姿を映し出す鏡となったのかもしれない。

デスク・ジョブ　　　　　　　　　　　　　　　　　　　　　　　　　　　　　　　　　p. 022
2009年
ミクストメディア・スカルプチャー、テキスト

ある著名な、しかしフラストレーションを抱えた作家が、すみずみまで整えられたモダニズム建築の自宅に住んでいる。作家は、自宅のそれを模した縮小レプリカの机に向かって自伝を書こうとしているが、次第に自分の性的経験の記憶に取り憑かれていく。それは激しさを増していき、まるで神殿のような自宅のミニマリズム的要素をみだらな性的行為で汚していく、という妄想に没頭する。

フローズン　　　　　　　　　　　　　　　　　　　　　　　　　　　　　　　　　　　p. 023
2010年
ミクストメディア・インスタレーション

アートが他の権力を凌駕して社会を支配していたことを示す、ある古代文明の遺跡をかたどったシリーズ。この古代都市はやがて滅亡するが、それは自己の像に取り憑かれたためであった。

インペリアル・テイスト　　　　　　　　　　　　　　　　　　　　　　　　　　　　　p. 026
2013年
ミクストメディア

1970年代に、彼らは東京の帝国ホテルで出会ったのだろうか。
フランク・ロイド・ライト設計のこのホテルが、竣工直後に大地震に見舞われた意味とは。
なぜこのホテルはあんなにも愛なく建て替えられたのだろう。
初めてのデートで、彼らが栗のモンブランを食べたというのは本当だろうか。
なぜ、彼らは、結局離婚したのだろう。

テオ・グリュンベルクの私的な財産
2010年
パフォーマンス、インスタレーション、ヴィデオ

p. 028

テオ・グリュンベルクは1872年に生まれ、136歳で亡くなった。彼はその間、ドイツ近代史の展開をつぶさに見た。熱心な本のコレクターだった彼の蔵書は、科学、言語学、美術、そしてエロティカに取り憑かれた男の物語だった。ベルリンの蚤の市で、私は彼の孫から何千もの本、レコード、日記、手書きの劇脚本からなるこの蔵書をまるごと買い取った。この品々は、20世紀のめざましい変化や悲惨なできごとに翻弄された男の人物像を映し出すようになった。謎めいた人物に突き動かされるように、私は彼の足跡を辿り始めた。ドイツからイスタンブールへ、そしてアマゾンの熱帯雨林の奥地へと。そしてある日、私にテオ・グリュンベルク本人に面会する機会が訪れた。私が2年間かけて創りあげたテオ・グリュンベルクの像は、彼がすでに亡くなっていることで初めて成り立つものだった。私は、面会を断った。

ファラシーズ
2010年
インスタレーション、ヴィデオ

p. 030

4人のイギリス人建設作業員が、中東のとある場所に建設中だった美術館の敷地から、男性器の形に彫られた石の古代彫刻を発見した。すぐに埋め戻されたのか、壊されたのか、あるいは売られたのか、その後この彫刻の行方はわからない。十数年後、彼らは集まり、覚えていることを語り合ったが、それぞれの記憶する彫刻は、サイズや形、素材すら違っていた。彼らは自分たちの記憶にできるだけ忠実に、その彫刻を再制作することで合意した。

メキシコからの手紙
2011年
ミクストメディア

p. 033

2010年冬、メキシコシティの路地をぶらついていたとき、僕はサントドミンゴ広場に偶然たどり着いた。石畳の広場はコロニアル建築に囲まれていて、そこは文字、紙、印刷に関するあらゆるものを扱う露店でいっぱいだった。これが2010年の光景？ なんてロマンティックなんだ！ と僕は驚いた。広場の一角の、列柱の前の店先には男たちが並んで座っていて、その横では人々が手紙にしたいことを口述していた。多くの人は読み書きができないため、男たちがタイプライターで手紙を代筆しているのだ。僕はその光景に衝撃を受けた。まるでパフォーマンスじゃないか。口述する人と代筆者の間を言葉が舞い、捉えられ、小さな文字の形に変換され、紙の上で永遠に凍結される。僕は暇そうなタイピストの横に座って、彼が理解できないにもかかわらず英語で話し始めた。「聞こえたとおりに書いてくれない？」僕は頼んだ。「僕がなにを言っているか当てようとしないで」。しばらく拒絶が続いた後、彼は聞こえたままを書き起こし始めた。

 しないなるよろっぷ、これは2010—2011ねんのふゆ、メキシコシティにたざいしているときに、サントドミンゴひろばのろじょたいぴすとにかきろこしてもらったへいごのてかみのしりずです。これは、メキシコがすぺにんからとくりつしたメキシコかくめいのひやくしゅうにんのきにんです。

 このてかみは、すぺにんじんのせいふくしや、エルナン・コルテスが、スペインおうにメキシコはっけんをしらさるてかみにじょくはつされてかいています。

こうして最初の手紙が始まった。

僕は、メキシコで見たことを話し始めた。この国の問題だらけの政治状況、路上の光景——良識ある旅人として考えたことを。タイピストたちのことも話した。彼らは理解できないのに。

 ぼくがはなしたることをしつたら、かれはとうおもふだろう？

最初の手紙を手に僕は家に帰り、それを読み直した。もっと書きたくなった。色彩と刺激に満ちたこの国で取り戻した僕の感覚のことを、なんの負荷も責任も感じられないぬるま湯のようなヨーロッパ世界の生活のことを、文字にしたかった。ヨーロッパ人である僕の遠い祖先が犯した過ちによって、この国の人たちはもともと欠陥のある国を受け継がなければならなかった、その罪を償うという新たな情熱に突き動かされて、僕は毎週その広場に通い、7週間にわたって手紙を書いてもらった。しまいに彼らは嫌気がさして、「売り切れ」だ、つまり「もう疲れた」と言った。僕は頼み、すがった。そして怒って、命令した。やるんだ！ 結構なお金を積んだ。それでも彼らは断固として働こうとしなかった。結局僕も疲れ切ってしまい、自分で手紙を書いた。

親愛なるメキシコへ

赦してください 僕はただヨーロッパ人なだけです：

お金が効かないときには　説得がある。
説得が効かないときには　攻撃がある。
攻撃が効かないときには　もう手段はない　あるのは詩だけ。

泥棒日記、ではない
2013年
手稿、金庫、ケース

p. 034

メキシコ滞在について言うと、サントドミンゴ広場で路上タイピストに打ってもらった一連の手紙は、別の当座の仕事を中断せざるを得なかったものの、私に自分の小説を書かせるにいたった喜ばしいできごとだった。この物語は現代のメキシコを舞台にしながらも、支配階級のヨーロッパ人の命令を拒否したメキシコの現地人が、復讐として反逆と動乱を起こし、その渦に巻き込まれていく旅人の姿が描かれる。ある場面では、スペインの独裁者フランシスコ・フランコが生き残っていることがわかるが、メキシコの片田舎の農場で齢を重ねるフランコは、蘭に囲まれながらファベルジェの卵の一大コレクションを愛でている。私は2カ月にわたって執筆を続けた。朝、太平洋の広大な水平線を望むテラスで風に吹かれながら書き、午後は陽を浴びながら朝書いたものを読み返す。が、この小説は宙に浮いた。そして気がついたのは、このめくるめくような数カ月間がどれほどの悦楽に満ちていたことか、ということだった。表層的かつ派手で退廃的なこの散文は、危険ではないにしても政治的にはあまりにも初心（うぶ）で、私はその小説を破り、メキシコシティ滞在の最後の数日間に骨董屋で買った鍵つきの金庫にしまい込んだ（後にその骨董屋はナチスのシンパだったことがわかった）。金庫は、メキシコ一の悪名高いいかさま師／泥棒「チューチョ・エル・ロト（ボロをまとったチューチョ）」の伝記の表紙で覆ってカモフラージュした。

芸術家愛読書倶楽部（はっくるべりぃ・ふぃんのものがたり）
2010年
ヴィデオ・インスタレーション

p. 035

『ハックルベリー・フィンの冒険』を大人になってから原書で読んだとき（子供の頃、日本語訳を読み聞かせてもらっていた）、実はハック・フィンはひどくやんちゃで反抗的な子で、ジムは黒人だったということを初めて知った。

再会のための予行演習
2011–2013年
ヴィデオ、インスタレーション

p. 037

人生のほとんどの期間、父と疎遠だったという理由で、僕が不満や恨み、よりどころのなさを抱えているのだろうと決めてかかる周りに、僕は嫌気がさしていた。安定した幸せな家庭に育ちながらも、そんな

「問題」を抱えている人はたくさんいるというのに。なぜ彼らは僕だけがそうだと思うのだろう。
この疑問がきっかけで、僕は長年会っていなかった父と再会するために日本に向かった。なにを確かめたいのかははっきりわからなかったが、寡黙な父といったいなにを話せばいいというのだ。僕たちが疎遠なのはきわめて普通のことだというのに。

僕たちは、一緒になにかしようということになり、美術と工芸が共通の興味だったこともあって、父の建築事務所の前にある陶芸教室に参加することにした。そこは日本のとある小さな町で、僕が育ったところだった。僕は、陶芸家のバーナード・リーチ（英国陶芸の父として知られる）が作ったティーセットを携えて行った。リーチは僕の地元セントアイヴスに住み、当時の最先端として西洋と東洋の美学を融合した人物である。

僕たちはこの巨匠のお手本を前にそれとそっくりなものを作ろうとした。はじめは簡単そうに思えた。しかしろくろから生まれたのは、よれよれに形のくずれた、なんとも不格好な代物だった。そこで僕たちは男としての行動をとった——比べたのである。気にくわなかった。この世では、主は一人であるべきだ。ふたりは無言で同意した。ふたつのティーセットのうち、ひとつは失せるべきだ！

だから僕はバーナード・リーチのティーセットをハンマーで粉々に壊した。よりどころに問題があるから、というわけではなかった。

フューチャー／パーフェクト　　　　　　　　　　　　　　　　　　　　　　　　　　p.040
2012年
パフォーマンス

ヨーロッパにわたってきた無職の若い移民が、ビジネス英語を学ぶ。

レベッカ　　　　　　　　　　　　　　　　　　　　　　　　　　　　　　　　　　p.043
2012年
彩色した石膏、ヴィデオ、インスタレーション

16歳のレベッカは、2011年のロンドンの暴動に参加して逮捕された貧困層の若者で、その後忘れられない思い出となる2週間の中国への旅に連れ出された。更正プログラムの一貫として、レベッカは工場見学に連れて行かれた。そこは、液晶テレビや彼女が普段着ているようなスポーツウェアが生産される製造工場だった。2週目には兵馬俑（へいばよう）を訪れ、偉大で、従順な、そして悠久の歴史を持つ国家による大量生産を目にした。その後レベッカは工場に連れて行かれて、全身を型取りされ、その型からは彼女そのもののようなテラコッタ色の石膏像が大量に造られた。現在までに、130体あまりが製造されている。

スタジオ・ピエタ　　　　　　　　　　　　　　　　　　　　　　　　　　　　　　p.053
2013年
ヴィデオ、写真、インスタレーション

オリジナルの写真とかなり違う？

そうだね、ちょっと違う。そもそも、事前にある程度わかっていたけど。でも思ったよりも彫像みたいで、生きてる感じがしないね。

オリジナルはどんな写真だった？

ビーチで撮られた写真。白黒だった気もするけど、空はたしかに青かった。男が写っていた。毛深くて黒髪の男が、母を抱き上げて砂浜に立っていた。水着姿でね。ふたりとも濡れていた。さっきまで泳いでいた感じ。

彼らの表情は？

母の表情は奇妙だった。幸せそうだったけど。はじめて見る顔つき。こう……無責任に幸せな感じ。
男の表情は忘れたけど、とにかく気に入らなかった。チャーミングだけど危険な顔。誰でもそう感じると思う。母親を抱いている男だからね。

「無責任に幸せ」とは？

その……いろいろ思い浮かべた。母とこの男が結婚していたら？ ベイルートで子をもうけて、僕もそこで生まれた？ 家族で生き延びることはできた？ 妄想が止まらなくなった。子供だからね。「無責任」とはそういうこと。

エロティックな写真だった？

いや。

彼に魅力を感じなかったんだね？

［無音］

ステートメントを読み上げてほしい。この本の84ページ。

いいよ……。

「キングコング・コンプレックス」

キングコング・コンプレックスとは、褐色の肌や豊かな体毛を持つ男性に恐怖を抱く個人あるいは文化の心理を指す。

歴史的に関係があるのは、エキゾティシズムやロマンティシズム、コロニアリズムの盛衰などである。

この心理状態では浅黒い肌の男性が、たとえば強い精力を象徴する。カサノヴァがそうだったように。それは原始的で基底的な熱情、および破壊的な傾向を伴う。そのとき主な破壊の対象となるのは、市民社会を支える諸制度である。

ポンペイの性表現から日本の漫画まで、男性は女性より暗い肌の色で描写されてきた。支配する側としての暗い色、支配される側としての白。この関係は「キングコング」において覆される。
コングをなだめられるのは、金髪の踊り子だけなのだ。

ありがとう。君のお母さんはダンサーとしてどんな暮らしを？

所属していた一座は「ブルーベル・ガールズ」。パリを拠点として、60年代当時ホットだった場所をわたり歩いた。モナコ、シンガポール、東京。67年か68年に、彼女はベイルートに住んでカジノで踊っていた。基本的にはキャバレー風のダンス。でもスケールは桁違い。コスチュームもセットも豪華。彼女たちのパフォーマンスの間、人々は食べたり飲んだり。ブルーベル・ガールズは厳格だったらしい。
見た目や振る舞いの決まりが多かった。母はそれを「グラマラスさの優生学」と言い表していた。均一な体型が求められた。一定の足の長さと胸や腰のサイズ。そして金髪で足を振り上げられること。
つまりそれは、完璧な西洋の女性という理想を輸出する産業だった。たぶんそういう意味での「優生学」。

どうやって撮影現場の砂浜に？

カジノを出て、視線を落としたら入り江があった。そのとき直感した。「あの砂浜に行かなければ」と。
着いてから振り返ると丘の上にカジノが見えて、砂浜に視線を戻すと海水が煌めいていた。
記憶のスイッチが入って、あの写真を急に思い出した。砂浜で男に抱き上げられる母。写真を見た経緯は思い出せなかったけど、「ここがあの場所だ」と確信した。

リサ・オーティングハウスを君のお母さん役に選んだ決め手は？

女性役を選ぶにあたっては、ブルーベル・ガールズと同じ基準にした。金髪およびダンサーの体を持つこと。候補を4-5人に絞って、オーディションで写真も撮った。
でもそこから先が難しかった。正直なところ……誰でもいいというか。みんな条件に合っていたから。おかしな話だけど、彼女はもっとも母からかけ離れていた。でも彼女の振る舞い方が気に入った。22-23歳の母が目の前に座って、あんな態度を取っていたらと思うと。

ボーイフレンド役はどうやって選んだ？ 探したときの基準は？

男性で、中東っぽい見た目。22歳から35歳の間。それだけ。アラブっぽい外見のモデルはベルリンにあまりいなくて、仕方ないので募集をかけたら、すぐに100通くらいの応募が届いた。
困惑したよ。モデル事務所が考慮するのは、役者の出身地ではなく外見だけ。だからイタリア人や南米系のモデルもいた。

どうやって最終的な決断を？

ふたりまではなんとか絞ったけど、そこから自分では決められなくて。リサに頼んで、わざわざそのために来てもらった。彼女はデイヴィッドを選ばなかった。僕はがっかりした。そのとき気づいたんだ。僕が望んでいたのは彼なんだと。そういうこと。

デイヴィッドの民族的な出自は？

［無音］

デイヴィッドがこれまで演じてきた役は？

彼が初めて出演した映画は『唐辛子みたいにホット』というタイトルで、ラブコメだった。自助グループに所属するセックス中毒のスペイン人の役。他の映画ではアラブの族長を演じたことも。ドイツに妻を連れてきて人工授精をしようとする。映画はその顛末を描く。ドバイ出身の男を演じたこともある。「ビッグ・ビジネス」を合言葉に、宗教的な着信音で一儲けを狙う。

彼はいつ俳優として頭角を現した？

2005年だね。スピルバーグの『ミュンヘン』で注目された。題材はイスラエル選手団の殺害事件。彼は「黒い九月」のメンバーを演じた。製作は極秘だったから、警備が厳重だった。あるとき彼は、通行証を携帯せずに現場に入ろうとした。警備は大騒ぎ。彼を捕まえて尋問した。攻撃のために侵入したと疑われたんだ。70年代の衣装はそのための変装だと。

なぜもともとの役割を入れ替えて、女性が男性を抱き上げることに？

どうだったかな。たしか言い出したのはデイヴィッドだった。リサに抱き上げられるのはどうかって。ふざけて言ったんだろうけど。決まった役しかもらえないことについて、ずっと愚痴っていたから。
50—60年代の主婦と比較していた。彼女たちの役割は綺麗でいること、台所に留まること。最初は話が飲み込めなかったけど、彼は自分が被害者だと感じているみたい。そして彼の妻の話になった。
彼女はたまたま金髪の…… 金髪のドイツ人女優で。幅広い役のオファーを受ける。彼女は俳優として彼よりずっと自由なんだ。自分のイメージを管理できている。

それで君が役割の交換を決めた？

まあね。彼に言われてピンときた。とにかく、やってみると難しかった。彼はリサが持ち上げるには重すぎて。吊るための装置をその場で作った。もちろん後で写真をいじくる前提で。
でも絵的にうまくいかなかった。

イメージと違った？

母の写真が頭にあったからね。だから、出来上がった画面は不自然というか、ぎこちない感じ。でもそういう彼らの姿をありのまま示すべきだと思った。というか、そう、まあ、どうかな……。

ツールズ I p.064
2013年
銅製のフリント(燧石)、アップル社製品

古いもの、新しいもの。

岩について考える
2013年
コンクリート製の岩、ミクストメディア

ベルリン自由大学 — 地学部 — 鉱物・岩石学研究室
マルテーザー通り 74-100 — D-12249 ベルリン

地学部
鉱物・岩石学研究室
博士研究員 ラルフ・ミルケ
マルテーザー通り 74-100
D-12249 ベルリン

サイモン・フジワラ様

電話 　(++49 30) 838 70 864
ファクス (++49 30) 838 70 763
Email: milke@zedat.fu-berlin.de

2015年12月7日 ベルリン

調査対象の岩の耐久性について

前略、調査をご依頼の岩の耐久性についてお送りします。
このご依頼は大変興味深いものでした。
調査の結果判明したのは、この岩はコンクリートで出来ていること、
少なくともサンプル採取を行った表層部分はコンクリート製であるということです。

コンクリート構造物に関しては非常に多くの科学的な調査研究がなされています。
一例を挙げると、1990年に社会主義の崩壊および東西ドイツの統一が起こった後、
国内のアウトバーンの補修が行われましたが、20年前当時はコンクリートの劣化および
その要因についての情報が不充分だったため、せっかく補修された道路は早々に
また劣化してしまいました。当時かけられた補修費は1億ユーロにのぼります。

劣化の要因の第一に挙げられるのは水、続いてアルカリ分です。

この世の生物にとって、水は生命そのものですが、岩にとっては死を意味するのです。

乾燥下で保管されるならば、この岩は1000年にわたって安泰でしょう。
科学界はこの50年の間に石造りの建物を風化から守る術を編み出しています。
この岩を1000年、あるいはもっと長い期間にわたって保存する方法も、近日必ず見つかるでしょう。
この岩を1000年守るほうが、アウトバーンを今後25年保たせることよりずっと安価です。

敬具

ラルフ・ミルケ

日本の南部のある神社の境内に、屋外でも1000年耐える作品をというコミッションを受け、4つの人造岩を設置した。コンクリート製のこれらの岩は、この神社の神職、庭師、幼稚園の園児の手によってうやうやしく設置された。諸事物に神性を尊ぶアニミズムが神道の起源であるとすれば、4つの岩は、それがなにでできていようと、遠い未来の参詣者に参拝されるのだろうか。

エコー・タワー
2014年
靴、オーディン・タワーから採られた金属部品、箱

1944年12月14日、デンマークのナチ工作員によって「芸術行為」として爆破されたオーディン・タワーから回収した金属片を使用して作られたタップシューズ。

ニュー・ポンピドゥ

2014年
石膏、生物的および非生物的素材

p. 081

1　はじめに世界は沼であった。

2　ポンピドゥ・センターはパリのマレ地区に建設されたが、「マレ」とはフランス語で沼を意味する。

3　1980年代、ポントゥス・フルテンはポンピドゥに双子の別館を建てたいと計画した。ほんの数百メートル先に、メカノ社の玩具のような、本館の部材とまったく同じものを使って別館を造ろうというこの計画は、実施されることはなかった。

4　私は18歳のときに初めてポンピドゥ・センターを訪れ、建築家になりたいという子供の頃からの夢を諦めた。このとき、屋上のレストランから薔薇を一輪盗んだ。

5　13年後、ドライフラワーにしたこの薔薇とともに私はマレに戻ってきた。ニュー・ポンピドゥという、私の計画した双子の別館を造りに。

6　私たちは、ポンピドゥの裏手数百メートルのところにあった空きビルを占拠した。建物の林立するこのマレ地区に、私たちはニュー・ポンピドゥを建てるのだ。

7　この建物に新しい生命の息を吹き込もうと、草や水生植物を植え、うさぎを飼い、地下を掘った。ニュー・ポンピドゥを建設するために、干拓された沼の土を掘っていった。

8　私たちは思った。ヨーゼフ・ボイスと彼の作ったフェルトの部屋を、ポンピドゥの修復専門家が3日の年休追加と交換で穴蔵のような暗い地下に潜っていったことを、ワーグナーとルートヴィヒ2世が音楽の渦に狂乱したことを、うさぎが建物中を縦横無尽に走り回っていたことを、雨樋の水落し口から1537年の雨水が流れ出てきたことを、私たちがニュー・ポンピドゥのために再制作しようとしていたポンピドゥの部品——半ば機械で半ば動物——のゲルブレット、ああ失礼、「ラ・ゲルブレット」が、沼の中から錆にまみれて見つかったことを。

9　ヴァレンタインデーのマレを行進しながら、私たちはニュー・ポンピドゥを展示室に運んだ。

10　そして、息をした。

驚くべき獣たち

2015年－
毛を刈った毛皮のコート、木材

p. 089

毛を刈って木枠に張った毛皮のコート。

仮面（メルケル）

2015年－
化粧品、麻布、木材

p. 095

最近誰かに、トリノの聖骸布は本物だと思うか——あのキリストの顔は、本当に亡骸を包んだ亜麻布に血が写し取られたものだと思うか、と訊かれた。私は答えられなかった。後になって私は、神が本当に存在して、神自身がこの聖骸布を作ったのならいいのに、と思っていたことに気づいた。キリストがこの世に存在した（として）、そのときの記録を切望する人々のために、神が与えた作りものだったらいいのに、と。

ある日、私はアンゲラ・メルケルのメイクアップアーティストと知り合う機会があり、彼女にスタジオに来てもらって、メルケルがテレビ出演する際に施すメイクアップをそっくりそのまま紙の上に描いてもらった。世界でもっともパワフルな女性の顔が、抽象的に、血色良く、もの言いたげに、しかも彼女であると認識できる形で現れたことに私は驚いた。政治のイメージ戦略がどのように働くのかを知りたくなって、私は

このメイクアップの絵を1000倍に拡大して模写し、首相のポートレートのシリーズを作ることにした。分割した彼女のポートレートを、実際に使っている化粧品と同じものを使って薄い麻布に描くというシステマティックな方法で、拡大された首相の顔の各部分が各キャンバスの上に再現された。実現されることはないだろうが、すべてのキャンバスを集めると彼女の顔全体ができあがる。

私 p.101
2015年ー
ミクストメディア、ブロンズコーティング

ドイツでは、各人のゴミ箱のコンパートメントに最適なものが選べるよう、200超の引き出し式ゴミ箱のユニットが販売されている。ほとんど宗教的とさえいえるドイツのゴミの分別は正しい倫理観を示すことにつながり、こうしたライフスタイルの推奨は、生産され続ける物資とその再利用という資本主義の論理を具現化している。このゴミ箱のヴァリエーションの中から選んだいくつかのモデルを、銅液でコーティングした。

ハロー p.107
2015年
HDヴィデオ

ダニエル・フジワラによる論考「幸福の経済学」を参照のこと。[p.190]

ヒストリー・イズ・ナウ p.115
2015年
ロンドンのヘイワード・ギャラリーにて企画した展覧会

イギリス最後の炭鉱から採取された黒光りする大きな石炭の塊

映画「マーガレット・サッチャー 鉄の女の涙」でオスカー賞を受賞したメリル・ストリープ着用の
マーガレット・サッチャーの仕事服

2011年のロンドン暴動の後、街を掃除する際に使われたほうき

イギリスの著名なアーティスト2名によって作られたゴミ袋の作品、一方はブロンズ製、一方は空気入り

アニッシュ・カプーアによるオリンピック・タワーの模型

デイヴィッド・ベッカムの寝顔、サム・テイラー=ジョンソン撮影、
JPモルガンおよびナショナル・ポートレート・ギャラリー協賛

ロンドンの金融街に建つ高級集合住宅用に造られたバルコニー

収監者が調理、サービスを行うイギリスの刑務所内に設けられた高級チャリティ・レストラン
「ザ・クリンク」のプラスチック製テーブルウェア

セレブシェフ、ナイジェラ・ローソンによる「サーヴィング・ハンズ」

大きな冷凍庫

デイヴィッド・ホックニーによる、iPadで描かれたイギリス郊外の風景画

ウェイトローズ・スーパーマーケットの、説明の多いハーブ、スパイス用パッケージ

プレム・サヒブによる、水滴が滴っているように見える金色のパネル

創造力促進のためにイギリス政府が制作した広告とする、ライアン・ガンダーの作品

ファロー&ボール社の色見本帳、裏返しに置かれ、色ではなく文字しか見えないもの

新聞から切り取られた、行方不明者マデレーン・マッキャン(当時4歳)の目の写真

他

当世風結婚
2015年
人造大理石、ブロンズ、金

世界一巨大なゲイのための結婚指輪。
ロンドンのポントン・ロード、エンバシー・ガーデン内にあるアメリカ大使館前に設置された。

あるマスクのためのパヴィリオン
2014年
アンティークのマスク、建築模型

アンティークのロシア製スターリンのマスクを購入し、それを収めるために作ったパヴィリオン。

乳糖不耐症
2015年
油彩、アクリル絵具、キャンバス

約7500年前、中央ヨーロッパの一部の人類に遺伝子変異が起こり、成人後の乳摂取に耐性を持つようになった。こうして人類は、生涯にわたって乳を摂取する唯一の哺乳類となった。とはいえ近年は、乳に含まれる糖類である乳糖に不耐症を持つ個体も増えてきた。乳糖不耐症者の割合は、ヨーロッパ北部で5パーセント、アフリカやアジア諸国のある地域では90パーセントと幅が見られる。この分布は、ヨーロッパのように食料源として乳製品が入手しやすい環境では耐性が高くなるといった、自然淘汰の一種と見なされている。

2014年、私は万寿台創作社――北朝鮮政府が運営する美術制作機関――に、コップに入った新鮮な牛乳の絵7点を注文した。4000人の従業員(うち1000人は絵画専門)を抱える万寿台創作社は、北朝鮮国内のあらゆるプロパガンダ絵画や記念碑、銅像を制作している。美術分野におけるこのような生産性の高さに反して、北朝鮮では生乳の生産が行われていない。北朝鮮政府はこの理由を明らかにしていないが、西洋の見方では、家畜の飼養管理体制の脆弱さや生乳運搬にかかる電気コスト、またはアジア諸国に乳糖不耐症が多く見られることなどが要因に挙げられている。

今日はミルクなし
2015年
牛糞、キャンバス

イスラエルの乳牛は、世界でもっとも高い生産量を誇る。研究によると、その理由は遺伝的なものとも科学技術によるものとも言われている。イスラエルでは、ホルスタイン種をもとに独自品種の改良が行われてきた。ホルスタイン種はドイツ北部のシュレースヴィヒ・ホルスタインを原産地とし、厳しい気候条件

にも順応する種とされている。飼料の種類は多岐にわたるが、33–35パーセントは小麦と牧草である。乳牛につけられた電子タグの情報は集中管理コンピュータに送られ、疾患の有無、体温、受精の必要などが管理される。この絵画シリーズは、イスラエル北部のエン・ハロードにあるキブツの酪農場で、搾乳中にキャンバスにもたれかかった乳牛が描いた作品である。乳牛は搾乳中に有益な副産物を排出するが、この有機的な排泄物は肥料となり、乳牛の飼料の栽培に再利用される。エン・ハロード・キブツは美術館や酪農場を擁する集産主義的な農業共同体で、設立当初の社会主義的な理念にもとづき、すべての収入が構成員に平等に分配される。

ブック p.144
2014年
iPad、ポルノ・ヴィデオ、本

他人のセックスを、見るのではなく、聞く。

ザ・ウェイ p.146
2015年
デジタルCプリント

どちらがよりエロティックだろうか？
ゲイ男優の生涯最後のほとばしりが、優雅に宙を舞う写真か？
それとも、人生の最期を目前にした彼が、病床で恋人に食事を食べさせてもらっている写真か？

Happy Birthday

p. 008

2008
Book, Wooden stand, Egg

Other people who were born on the 10th of September include Pope Julius III, Georges Bataille, and Rudolph Schindler.

The Museum of Incest

p. 010

2008–2010
Performance, slide show, Installation, Video

> When fathers love daughters and daughters love fathers it's like tying up into a knot the thread that runs into the future, it's like a stream wanting to flow backwards.
>
> Simone de Beauvoir

The Museum of Incest is an architectural project I developed after a journey I made to the Olduvai Gorge in Tanzania. Known as the Cradle of Mankind, it was the archaeological site where the grave of the 'first man' was discovered. Named *Homo habilis*, or Handyman, by the archaeologist Louis Leakey, the body was found buried with stone tools and flints, not only proving that *Homo habilis* was the first primate to walk upright, but also signaling the beginning of humanity's supremacy over other animals and the surrounding physical world. Flints are used to kill, to dissect — they were humanity's first weapons — and in this sense it is the flint that binds the beginning of human time to the end of human time, for how else will the world end if not through the tools we use for industry or our weapons of mass destruction?

If it is commonly believed that procreation is the purpose of life, and that through it time flows forward from one generation to another, then in incest practices, and particularly in parent-offspring incest cases, time loops — the stream flows backward on itself. It is this time conundrum that lies at the heart of the philosophical problem of *The Museum of Incest*, an imaginary museum proposed to be constructed with its foundations on the grave of *Homo habilis* in Tanzania.

Within its iconic, futuristic, built form, *The Museum of Incest* houses no artefacts or artworks, as almost all civilisations have regarded incest as taboo and have preserved no physical documents recording its existence. The museum relies entirely on ephemeral means to communicate its history. Its three main spaces articulate different periods in incest history, from ancient Egypt to the present day. Daily performances take place within reconstructions of spaces relevant to incest history, such as the European Court of Human Rights in Strasbourg, France. Famous incest cases are played out for visitors, such as the case of the brother and sister Stübling, a German locksmith and his sister-lover, who are currently seeking custody of their four children. In the following room visitors walk through and interact with a reconstruction of the destruction of Sodom and Gomorrah. Crucial to *The Museum of Incest*'s policy of responsibility to local economical and ecological regeneration, the architectural reconstructions are fabricated entirely from local African mud building techniques, and the actors are sourced from nearby villages.

Due to the climate conditions of the museum's location, much of the building is housed underground, away from the glare of the African sun. It is here in the basement that the museum café is situated, an important gathering place for visitors and perhaps the key to the museum's story. Decorating the southern wall of the café is a replica of a mural depicting an idyllic family meal scene, painted originally by my father for an Italian restaurant in Japan. Although our racial features have been changed from Japanese to Italian, the mural, which features both my father and myself, aged four, can be seen as both the architect's signature on the iconic building as well as a symbol of father-son repatriation, turning the tides of the stream.

Impersonator

p. 012

2009
Performance, Installation

During a residency at the Schindler House in Hollywood, California, I discovered that the Austrian actor and bodybuilder Arnold Schwarzenegger had visited the historic landmark

building at a point in his life when he was considering becoming an architect. Rudolph Schindler (1887–1953), another Austrian who had left the constraints of conservative Central Europe to explore his ideas of new lifestyles and well-being in California, could provide an example to Schwarzenegger as he considered his next career move. Ultimately, the Schindler house, with its oppressively low ceilings and numerous dark closets, reminded Schwarzenegger of the fatherland he had left. He became a politician instead.

I met Lyndall Grant, forty-seven, at the juice counter of Whole Foods on Sunset Boulevard and he told me his story. The son of an overbearing military father, he spent his childhood travelling before he settled in San Francisco and became a construction worker on skyscraper projects. Eventually he began training to become an architect. On a chance visit to Los Angeles, Grant was spotted by a talent agent for his uncanny physical likeness to Schwarzenegger. Schwarzenegger at that time was running for governor of California, and Grant, as his impersonator, was immediately booked for several months to appear as his double at various events and television spots. As his newly adopted career mirrored Schwarzenegger's increasing power, Grant had little time to pursue his architectural dreams and eventually gave up, becoming a full-time impersonator.

On March 13, 2009, Grant came to the Schindler House to give a one-time performance in the form of a 'walking tour' delivered from a specially designed treadmill installed in Schindler's former studios. As he talked about his life, and its uncanny synthesis with that of Schindler and Schwarzenegger, the pace of the treadmill increased until finally, exhausted and out of breath, his story came to an end.

Welcome to the Hotel Munber
2009
Performance, Installation

p. 013

A homoeroticised re-creation of the bar in the Hotel Munber, owned by Alison and Kan Fujiwara during the last years of the Spanish dictator Francisco Franco's reign.

Or

When you try to turn your parents' life story into an erotic novel.

Feminine Endings
2009
Performance, Video, Installation (with Timothy Davies)

p. 016

feminine ending
n. an unstressed syllable at the end of a line of poetry, verse, or musical phrase

In the canteen at art school, Timothy Davies and I discussed our childhood memories of learning the cello. We knew all the same musical scores, we realised, and we had been taught by similarly intense female teachers. Why were we so attracted to them, we wondered? What drew these two gay adolescents to this instrument, with its feminine form and deep voice?

The Last Castrato
2010
Record player, Steel sculpture, Record

p. 019

Castration before puberty prevents a boy's larynx from being transformed by the normal physiological events of puberty. Lacking testosterone as he enters adulthood, the castrato's limbs grow unusually long, as do the bones of his ribs. This expansive lung capacity operating through child-size vocal cords gives the castrato's voice a uniquely powerful yet delicate tone that was coveted for centuries. Castration was made illegal in 1870 in Italy, around the same time that modern sound recording technology emerged. There is only one surviving recording of the last castrato.

The Mirror Stage
2009–2013
Performance, Installation, Video

p. 020

Patrick Heron's *Horizontal Stripe Painting: November 1957–January 1958* was the first piece of modern art I saw in person, and it turned me gay. I was eleven when I saw it at Tate St Ives's inaugural exhibition. Entranced by the rich colours and dripping white oils, I felt a sea change taking place inside me. I was not aware of what it meant until years later, when I tried to write a play about the experience. Never staged, its subject was the impossibility of portraying how an abstract painting could evoke sexual realisations in a pubescent boy. In 'The Mirror Stage as Formative of the Function of the I as Revealed in Psychoanalytic Experience,' Jacques Lacan suggests that children seek mirrors to form their identities, and that during puberty this becomes sexualised. As the first abstract painting I'd ever seen, perhaps the absence of figuration and of gender was a mirror to my closeted pubescent self.

Desk Job
2009
Mixed media sculpture, Text

p. 022

A celebrated but frustrated writer is living in an exquisitely crafted modernist home. Sitting at his desk, itself a miniature replica of his home, and attempting to write his own biography, he becomes obsessed with the erotic memories of his early life. Slowly going mad, he begins to fantasise about the home he is enshrined within, committing indecent sexual acts that soil the minimalist architectural elements.

Frozen
2010
Mixed media installation

p. 023

A series of fabricated archaeological excavations tell the story of an ancient urban civilisation in which art has come to rule over all other forms of power. The city eventually saw its own destruction due to its obsession with its own image.

Imperial Tastes
2013
Mixed media

p. 026

Did they meet in the Imperial Hotel in Tokyo in the 1970s?

What does it mean that Frank Lloyd Wright's hotel was hit by a massive earthquake just after it was completed?

Why was it rebuilt so lovelessly?

Is it true that they ate Mont Blanc aux Marrons on their first date?

Why did they eventually divorce?

The Personal Effects of Theo Grünberg
2010
Performance, Installation, Video

p. 028

Theo Grünberg was born in 1872 and died at the age of 136, and saw the whole history of modern Germany unfold before his eyes. He was an avid book collector, and his library tells the story of a man obsessed with science and languages, art and erotica. I acquired his entire library from his grandson at a flea market in Berlin, and it includes more than a thousand volumes, records, diaries, and handwritten scripts for theatree plays. Together the artefacts go some way in portraying a man whose life was constantly manipulated by the exciting

changes and terrible events of the twentieth century. Obsessed with this mysterious figure and the traces he left in Germany, Istanbul, and the depths of the Amazon rainforest, I travelled around the world in his pursuit until, finally, on a chance encounter I was offered the opportunity to meet him in person. Realising that the image of Theo Grünberg I had constructed over two years could only exist if the man himself was dead, I declined the meeting.

Phallusies

p. 030

2010
Installation, Video

Four British construction workers saw an ancient carved-stone phallus being unearthed from beneath the foundations of a new museum under construction in the Middle East. Reburied, destroyed, or sold—nobody knows what happened to it. A decade later, the men reconvened and, amid arguments concerning its size, shape, and even its material, they finally agreed to remake the sculpture to the best of their memories.

Letters from Mexico

p. 033

2011
Mixed media

Wandering the streets of Mexico City over the winter of 2010, I came across the Plaza Santo Domingo, a flagstone square flanked by colonial buildings bustling with vendors selling all things related to writing, paper, and printing. What a romantic scene to see in 2010, I thought to myself! On one side of the square under a set of colonnaded shop fronts sat a row of typists, and beside them members of the general public, many of them illiterate, dictating letters. I was struck by the scene—it was like a performance—the air-bound words passing between speaker and transcriber, words captured and turned into small black hieroglyphs, frozen in time on paper. I took a seat beside an idle typist and began to speak to him in English, which he didn't understand. 'Write what you hear,' I told him, 'not what you think I am saying,' and after much protesting he began to transcribe phonetically what I said:

> Dir Europ, this seris of leters wer dictateitet in Inglish and transcraib bait ha strit taypists of Plz. Santo Domingo in Mexico City durin my stei ov winter 2010–2011. Thei mark da hondret years ov independens from Spein sins da Mexican Revolucion.

> Tha leters wor inspair bai Hernan Cortes, di Spanis conquistador hu descraibt that 'discoveri' ov Mexico in leteres tu da king of Spain.

So began the first letter.

I began to speak about my observations of Mexico—about the troublesome political situation, the scenes on the streets—musings of a tourist with a conscience. I began to describe the typists themselves, unbeknownst to them.

> Wot wud he sink if hi nu wot I was sayin?

After writing the first letter, I went home and reread it. I wanted to write more, to put into words the revival of my senses in this land of colour and spices, my former life in the cosseted world of Europe like a shell that no longer burdened me. Burning with a new desire to exorcise my guilt for the wrongdoings of my European ancestors from whom the Mexicans inherited a broken nation, I returned each week, for seven weeks, to write another letter and then another. In the end, the typists had had enough: 'Agotado' they would say, 'exhausted.' I begged, I pleaded; I grew angry and enraged—Work! I demanded. I offered money, too much money, yet they remained still, resolute. Finally, exhausted too, I wrote a letter myself:

> Dear Mexico,
>
> Forgive me but I am only European:
>
> When money does not work there is persuasion.
> When persuasion does not work there is aggression.
> When aggression does not work there is no remedy, only poetry.

Not A Thief's Journal
2013
Manuscript, Safe, Vitrine

p. 034

Speaking of my stay in Mexico, the letters I wrote with the street typists of Plaza Santo Domingo were a welcome respite from the main task at hand, which was to finally write a novel of my own. Set in present-day Mexico, the story would chronicle the life of a tourist drawn ever deeper into a circle of terror and violence (largely of his own imagining) in which revenge is taken by ethnically indigenous Mexicans who overthrow the order of the ruling-class Europeans. In one scene, the Spanish dictator Francisco Franco is discovered alive, living on a ranch in the Mexican countryside, growing old among orchids and tending to his vast collection of Fabergé eggs. Two months I was at my task, spending the mornings writing on a breezy terrace that overlooked the expansive Pacific horizon, the afternoons lazing in the sun and looking over my morning's work. But the novel went nowhere, and I soon realised what an indulgence had overcome me throughout those heady months. The work was structurally shoddy, with florid, decadent prose, and politically naive, if not dangerous. I scrapped the novel and locked it in a safe I bought from an antiquarian (who, it turned out, was a Nazi sympathiser) on my last days in Mexico City. The safe is camouflaged by book covers for a fake biography of Chucho el Roto, Mexio's most infamous fraudster and thief.

Artists' Book Club: Hakuruberri Fuin no Monogatari
2010
Video installation

p. 035

Only in adulthood, when I read the original version of *Adventures of Huckleberry Finn* (and not the Japanese translation, which was read to me as a child), did I discover that Huck Finn was in fact a naughty, disobedient boy and that Jim was black.

Rehearsal for a Reunion
2011–2013
Video, Installation

p. 037

I grew tired of people assuming that because I had been estranged from my father for most of my life I would have a chip on my shoulder, a score to settle, a problem with authority. Many other people have those 'issues' and come from stable, happy families. Why would they think I am different?

I travelled to Japan to reunite with my father after all those years, not quite knowing what I wanted to prove. What on earth would my laconic father and I discuss? Everything about our estrangement was perfectly normal.

We decided we should do something, and since we have a shared interest in arts and crafts, we enrolled on a pottery-making workshop at a studio just in front of his architectural offices in the village in Japan where I was brought up. I had brought with me a tea set made by the British ceramicist Bernard Leach (aka the father of British pottery) who lived in my hometown of St Ives in England and artfully fused Eastern and Western aesthetics at a time when such things were fashionable.

We tried our best to copy our master's lead and at first it seemed easy. But our misshapen creations emerged from the kiln shrunken and deformed. So we did what men do: compared things. And we didn't like what we saw. There is only room for one master in this world, we silently agreed; one of these tea sets has to go!

And that was why I smashed the Bernard Leach tea set into tiny little pieces with a hammer. Not because I have a problem with authority.

Future/Perfect
2012
Performance

p. 040

Young, unemployed migrants to Europe learn business English.

Rebekkah

2012
Dyed plaster, Video, Installation

p. 043

Sixteen-year-old Rebekkah, an impoverished criminal youth who took part in the 2011 London riots, was taken on a two-week journey of a lifetime to China. As part of her resocialisation program, Rebekkah was taken to see a factory where flatscreen TVs were produced as well as a sportswear factory where much of the clothing she wore originated. During the second week she visited the terra-cotta warriors, observing the mass production of a great, obedient, historic nation. Following this, Rebekkah was taken to a factory where a cast was taken of her entire body from which numerous identical terra-cotta-coloured plaster figures were produced. To date, more than 130 figures have been produced.

Studio Pietà

2013
Video, Photographs, Installation

p. 053

So it does not look anything like the original photograph?

No, not really. I mean, I didn't really know what to expect. I thought they would look less like sculptures. You know, more alive.

Could you please describe the original photograph?

It was taken on a beach. It may have been black and white but I remember the sky being blue and there was a man—a hairy, dark-haired man—holding my mother in his arms, and they were standing on the sand in swimwear. Both of them were wet. I mean, I guess they had just come out of the water.

Can you describe the expression on their faces?

She had a strange expression. She looked happy. But in a way that I've never seen before—sort of irresponsibly happy. And he—I don't remember the look on his face but I remember I didn't like it. He looked charming and dangerous at the same time. But you know you would think that of anyone who had your mother in his arms, wouldn't you?

Can you clarify what you mean by 'irresponsible looking'?

Well, I remember thinking, you know, what if she had married this guy instead? Would they have children born in Beirut? Would I have been born there? Would we have survived? You know, your mind runs away with itself as a child, doesn't it, so I think that's what I mean by irresponsible.

Would you describe the image as erotic?

No.

So you did not find the man in the picture attractive?

[Silence]

Could you please read the statement on page 84 of this book…

Ok…

> The KING KONG KOMPLEX.
>
> The KING KONG KOMPLEX is a phrase that describes a psychological state in which a person or culture at large lives in fear of the notion of a darker-skinned or hairy male individual.
>
> Historically it is linked with exoticism, romanticism, the rise and fall of colonialism, et cetera.
>
> In this state the darker male represents — among others things — sexual virility, as in the case of the Mediterranean Casanova. Primitive and base passions and a destructive tendency that is most commonly directed toward institutions that represent civil society.
>
> From the erotica of Pompeii to Japanese manga, male skin tones have historically been depicted as being a few shades darker than the female. This 'dark as dominant, white as passive' paradigm is reversed in the plot of King Kong, where Kong can only be pacified by a blonde showgirl or dancer.

Thank you. Could you please tell me more about your mother's life as a dancer?

She was a member of a troupe called the Bluebell Girls. They were based in Paris but lived temporarily in all the glamourous hot spots in the 1960s, so, Monaco, Singapore, Tokyo, and in '67 or '68 she was living in Beirut and dancing at the casino. It was cabaret dancing, essentially, but on an extravagant scale: lavish costumes and sets, all performed while people were eating and drinking at tables. The Bluebell Girls were pretty strict as far as I understand, you know, there were many rules on how to look and how to behave and so my mother used to describe it as a kind of glamorous eugenics project, in the sense that they had to fit a uniform body size, have a certain leg height, breast and waist size, and they had to be blonde and able to do the high kick. It was an industry, essentially, exporting the idea of the perfect Western woman. I think that's what she meant by eugenics.

How did you end up on the beach where the photograph was taken?

Well, I walked out of the casino and I looked down and saw this bay and something inside me told me I had to go down to that beach. From there I looked back at the casino on the hill behind, and I looked at the sand and the sea sparkling and something just triggered this memory of the photograph of my mother on that beach in the arms of this man and even though I don't remember where I had seen it, I was sure it was taken there.

How did you decide to cast Lisa Oettinghaus as your mother in the photograph?

The female model really only had to fulfill the Bluebell Girls' criteria—the blonde hair, the dancer's body. I brought in four or five dancers to the casting and made pictures, but it was difficult to choose because, to be frank, any of the dancers would have looked fine, they all fit the criteria. Funnily she was probably the dancer that least looked like my mother, but I liked the way she presented herself, her attitude. I thought that I would like to imagine my mother to have been like this when she was twenty-two or twenty-three.

What about the process of casting the boyfriend of your mother?
What were your search criteria?

Male, Middle Eastern looking, age between twenty-two and thirty-five. That was it. There were not many Arab-looking models to choose from in Berlin, so I ended up putting out a casting call for Arab-looking actors and suddenly I had about a hundred profiles sent to me. I got totally confused because for the agencies, it doesn't matter where the actor comes from, it's just how he looks, so they sent me Italian and South American men as well.

How did you make the final decision?

It came down to two guys in the end, and I just couldn't decide between them myself. So we called Lisa back and asked her to choose and she didn't choose David, and I felt disappointed. That was how I realised I had wanted him all along, you know?

What is David's ethnic origin?

[Silence]

Can you recall what kind of roles David has played?

His first-ever role was in a film called *Scharf wie Chilli*, which means 'hot like chili'. It was a romantic comedy in which he played a Spanish sex addict at a self-help group. In another role he played a sheik who has come to Germany to have his wife artificially inseminated and it was all about whether or not he could or couldn't do that. And there was one role where he played a guy from Dubai and he wanted to make 'big business'—that was his catchphrase— to get rich selling religious ringtones.

In which year did his career as an actor begin?

In 2005. His breakthrough was in a Steven Spielberg film called *Munich*, about the killing of the Israeli team at the Olympics. He played a member of the Black September group. The shoot itself was top secret with incredibly high security, and one day he went on set without his security pass and tried to get in, and the security went crazy and arrested him and started interrogating him because they believed he was planning an attack on the film production and had dressed up in the 1970s costume just to get on set.

Why did you decide to reverse the roles of the man and the woman in the photograph—to have the male in the arms of the female?

I'm trying to recall. As far as I remember it was David's idea to be held in Lisa's arms, although I'm pretty sure it was a joke at first. You see, he started going on this rant about how he'd never had any acting roles that were surprising, and he started comparing himself to housewives in

the '50s and '60s, how they had this role to just look pretty and stay in the kitchen, and I didn't really see the connection at first but I think that his point was that he felt victimised. He started talking about his wife, who happens to be blonde—a blonde German actress—and he said she hardly ever gets typecast at all, that she has more freedom than he does as an actor and is more in control of her image.

So it was your idea to have him in her arms?

Well I wouldn't have thought of it if he hadn't have told me that. Anyhow, there were problems on set. Lisa couldn't hold him in her arms so we had to build this hanging contraption to suspend him, with the idea of course of Photoshopping them together in the end, but they just didn't look right.

What did you have in mind?

I had the original picture of my mother in my mind, of course. So when I saw it they just didn't look natural or… there was no ease to the picture. But I thought it was important to represent them as they saw themselves, or, yeah, you know, I don't know…

Toolz I
2013
Bronze flint, Apple product

Something old and something new.

The Problem of the Rock
2013
Concrete cast rocks and mixed media

Freie Universität Berlin · FB Geowissenschaften – AB Mineralogie-Petrologie
Malteserstr. 74-100 – D -12249 Berlin

FB Geowissenschaften
AB Mineralogie-Petrologie
PD Dr. Ralf Milke
Malteserstr. 74-100
D-12249 Berlin

Telefon (++49 30) 838 70 864
Fax (++49 30) 838 70 763
Email: milke@zedat.fu-berlin.de

Berlin, 07.12.2015

Dear Simon Fujiwara,

Durability of the investigated rock

You asked for the durability of the investigated rock. This is a very good question. One thing we know from our investigation is that the rock is made out of concrete or at least its outer parts that were sampled.

Concrete structures are a matter of intense scientific research. As an example, after the collapse of Communism and the German reunification in 1990 many 100s km of Autobahn have been repaired, but they are worn down again well before their time because just 20 years ago the degradation of concrete and the factors leading to early degradation have not been known deep enough. The costs of early repair are 100s millions Euros.

The most devastating agent is water. Second is alkalis.

For organisms of our world, water means life; for rock it means death.

If the rock is stored in a dry place it might reside there for the next 1000 years. Over the last 50 years scientists have discovered many methods to keep building stones from weathering. Future insight should be able to preserve the rock for 1000 years or much longer. Preserving the rock for the next 1000 years will be much cheaper than preserving the Autobahn for the next 25 years.

All the best,

Ralf Milke

Four artificial rocks were installed in the gardens of a Shinto shrine in southern Japan for a commission for outdoor artworks that should survive one thousand years in the open. The concrete rocks were installed in a procession involving the priests, gardeners, and kindergarten children of the shrine. Considering that Shinto is an animist faith that honours the sacredness of the material world, could the rocks, in all their artifice, be worshipped by future generations of shrine visitors?

Echo Tower p. 078
2014
Shoes, Metal parts from Odin Tower, Box

Tap-dancing shoes made with metal from parts salvaged from the Odin Tower in Denmark, which was bombed on December 14, 1944, by a group of Danish Nazi saboteurs who claimed the bombing as an artistic act.

New Pompidou p. 081
2014
Plaster, Biological and non-biological materials

1. In the beginning, the world was a swamp.

2. The Centre Pompidou is built in the Parisian district of the Marais, which is French for 'swamp'.

3. In the 1980s Pontus Hultén wanted to make a twin Pompidou, just a few hundred meters away, built in the exact same meccano-like parts, but it never happened.

4. I stole a rose from the rooftop restaurant of the Centre Pompidou when I was eighteen and, upon seeing this building for the first time, gave up my teenage dreams of becoming an architect.

5. With that dried rose I returned thirteen years later to the Marais to begin construction of my own twin institution called New Pompidou.

6. We occupied an empty building a few hundred meters away, in the shadow of the Pompidou, in the swamp of buildings in the Marais where we would construct New Pompidou.

7. We breathed new life into that building, growing plants and swamp weeds, breeding rabbits, and excavating the basement, into the dried swamp earth, as we started construction of New Pompidou.

8. We remembered Joseph Beuys and his rotting felt room, we remembered the Pompidou conservators in their burrows underground with three days of extra holiday a year for their life in the dark. We remembered Wagner and King Ludwig II going mad in a swamp of music, the rabbits running freely about the buildings, the gargoyles spewing rainwaters of 1537, and the Gerberette, oh *La Gerberette!* The fragment of the Pompidou—part machine, part animal—that we were re-creating, the only fragment of New Pompidou discovered in the swamp decaying as it comes into existence.

9. We brought New Pompidou in a procession through the streets of the Marias to be placed in the museum on Valentine's Day.

10. We breathed.

Fabulous Beasts p. 089
2015–
Shaved fur coats, Wood

Fur coats shaved and stretched on wooden frames.

Masks (Merkel)
2015–
Makeup, Linen, Wood

Someone recently asked me if I thought that the Shroud of Turin was real or a forgery—if I believed that it really was the bloody imprint of Jesus's face on the shroud he was supposedly enshrined in. I couldn't answer. I later realised that what I secretly hoped for was that indeed there exists a god, and that he would be perverse enough to have produced the Shroud of Turin himself, to have created a forged but highly desired document of Jesus's time on Earth, if indeed Jesus ever existed.

I got to know the makeup artist for Angela Merkel, who came to my studio and painted on a piece of paper a replica of Angela Merkel's face with the chancellor's own makeup, as if she were making up her face for a television appearance. I was struck by the image of the world's most powerful woman, abstracted, peachy and gestural but still recognisable. I wanted to understand how political imagery works, so I decided to create a series of portraits of the leader and copied and enlarged her makeup portrait to one thousand times the original size. Systematically, I began to paint fragments of her portrait using the same makeup on thin linen, each part of her blown-up face on a separate canvas that together would create a whole, never to be shown together.

Ich
2015–
Mixed media, Bronze coating

There are more than two hundred variations of retractable trash cans available in the German market to suit each individual customer's required compartmentalisation. Representing an ethical posture, the almost sacred practice of precise waste separation in Germany is an endorsement of a particular lifestyle that incarnates the capitalistic logic of constant growth and reutilization of resources. For this work, selected models are coated in liquefied bronze.

Hello
2015
HD video

See essay 'Happy Economics' by Daniel Fujiwara [p.192]

History is Now: 7 Artists Take on Britain
2015
Curated exhibition at Hayward Gallery, London

A large, glazed piece of coal from Britain's last coal mine

The uniform of Margaret Thatcher as worn by Meryl Streep for her Oscar-winning performance in *The Iron Lady*

Two brooms used to clean up after the London Riots in 2011

Two rubbish bags as artworks by renowned British artists, one made of bronze, the other filled with air

Anish Kapoor's model for the Olympic Tower

David Beckham sleeping, filmed by Sam Taylor-Johnson, sponsored by JP Morgan and the National Portrait Gallery

A balcony produced for a luxury housing complex in London's financial district

A set of plastic tableware from The Clink, a charity offering high-end dining in
British prisons with food prepared and served by inmates

'Serving Hands' by the celebrity chef
Nigella Lawson

A deep freezer

A drawing of the British countryside executed on an iPad
by David Hockney

Some verbose herb and spice packages
from Waitrose supermarket

A golden panel with droplets of artificial sweat dripping down it,
by the artist Prem Sahib

An advertisement promoting imagination, supposedly produced by the British government, an
artwork by Ryan Gander

A Farrow & Ball paint chart turned upside down,
where the words but not the colours are visible

A newspaper cutout of a picture of
the eye of Madeleine McCann, who went missing at age four

Etc.

Modern Marriage p. 123
2015
Marble resin, Bronze, Gold

The world's largest gay wedding ring sits in front of the American embassy in the Embassy Gardens, Ponton Road, London.

Pavilion for a Mask p. 127
2014
Antique mask, Architectural model

I bought an antique Russian mask of Stalin and designed a pavilion for it.

Lactose Intolerance p. 130
2015
Oil and acrylic on canvas

Around 7,500 years ago a genetic mutation emerging in central Europe caused a development in some human populations that enabled them to tolerate the ingestion of milk well into adulthood. As such, humans are the only mammals that continue to ingest the substance throughout their lives. More recently, however, some human populations have developed an intolerance to lactose, a sugar found in milk. The frequency of lactose intolerance ranges from 5 percent in Northern Europe to 90 percent in some African and Asian countries. This distribution is now thought to have been caused by natural selection favouring individuals in cultures such as Europe, in which dairy products were available as a food source.

In 2014 I commissioned the Mansudae Art Studio—North Korea's state-run art production facility—to produce a series of seven paintings of a simple glass of fresh milk. With more than four thousand employees, one thousand of whom are trained artists, the Mansudae Art Studio produces all of North Korea's propaganda imagery and monumental bronze statuary. Despite their highly developed production capabilities in the field of art, North Korea

produces no fresh milk. While the state offers no official reasons for this, numerous Western theories abound: from the poor treatment of their livestock and high electricity costs associated to transporting fresh produce to the dairy intolerance common among Asian nations.

No Milk Today
2015
Cow manure on canvas

p. 137

Israeli cows produce the highest yield of milk per cow than those of any other nation in the world. Researchers posit a number of reasons why, ranging from the genetic to the technological. Israelis have developed their own breed based on the Holstein; originating in the region of Schleswig-Holstein in northern Germany, the Holstein is claimed to be more adaptable to harsh and varied climatic conditions. Its varied diet contains around 33 to 35 percent wheat and silage. Their electronic tags transmit to a central computer information detecting sickness, or heat and the need for immediate insemination. This series of paintings was made by Israeli cows as they rested against canvases during their milking sessions at the Ein Harod Kibbutz in northern Israel. During their lactation, the cows excrete useful organic by-products that can be reused as fertilizer for crops from which cow feed may be produced. In the spirit of the early settlers of the state of Israel, Ein Harod Kibbutz is an agricultural community that features an art museum and dairy farm and continues the socialist ideology of equal income distribution among its members.

Book
2014
iPad, Porn video, Book

p. 144

Hearing but not seeing people having sex.

The Way
2015
Digital C-prints on archival photo paper

p. 146

What is more pornographic? Photographs of a gay porn star's last seed as it flies gracefully though the air? Or a picture of him in the hospital being tenderly fed by his boyfriend, just days before he died?

Chapter 3　Essays

鏡の中に見えるもの
サイモン・フジワラが映し出す
私たちの姿

野村しのぶ

(魔女)三人
いいは悪いで悪いはいい、
濁った霧空飛んでいこう。

ウィリアム・シェイクスピア『マクベス』
小田島雄志 訳[01]

わたしの窓は 靄に向かっている
その靄はすべてであり そのうちに宇宙がある……
みずからを探すなら わたしの目のなかに読むのは
仮想の時 わたしはそれをみずからのうちに
立ち上げる。

［中略］

ああ 無人島 わたしの海のなかの
わたしの意識の奥底の！
そしてわたしたちのあいだにあるのは
世界の不正確さ。

フェルナンド・ペソア「無人島」
福島伸洋 訳[02]

サイモン・フジワラが、母国日本の美術館で初めての個展を開催するにあたって「ホワイトデー」を展覧会タイトルの候補に挙げたのは、準備のかなり早い段階だった。そのころからフジワラはこの展覧会を、「システム」という切り口で自身のこれまでの作品を検証し、その切断の林立によって自らの作品を、そして私たちが生きる社会を分析する機会と考えていたのだろう。およそ多様な人間の社会を、秩序立て、方向づけ、規範立てるために人間が生み出した「道具」であるシステムは、社会のあらゆる場面において私たちの思考、行動の前提として連続的に働いている。これにもとづく判断の積み重ねが、結果として良識や倫理といったより個人的なレヴェルにまでシステムの論理を浸透させているのだが、システムが広範にわたってうまく構築されていればいるほど、私たちはそのことに無自覚になる。

ホワイトデーとは日本独特の歳事で、ヴァレンタインデーに女性からチョコレートをもらった男性が返礼のプレゼントを贈る日である。そもそも日本では、ヴァレンタインデーが「意中の男性に女性がチョコレートを贈る日」として定着しているが、この歳事は製菓会社が販売促進のために欧米の慣習を輸入・変形し、営利的な仕掛けとして利用した結果、成功した例である。感情を表に出す機会が少ない日本社会で、また女性から男性へ愛を告白することがはばかられた時代において、2月14日は堂々とタブーを破れる特異日となり、小学生から大人まで幅広い世代に支持されるお祭りとなった。興味深いのは、この慣習をさらに商業的あるいは儀礼的に利用する動き——「義理チョコ」なるカテゴリーが発生したことである。恋愛の対象ではないけれど仲良くしていたい人や、職務上で関係する上司・同僚・得意先の男性に「日ごろの感謝を込め」て贈る、本命チョコよりはるかに小さなサイズのチョコレートも商品ヴァリエーションに加わった。こうなると、チョコレートをもらった男性のお返しも儀礼化しなければならない。そこで生まれたのが1カ月後、3月14日のホワイトデーで、月が明けると店舗ではキャンディー、ハンカチ、アクセサリーなどが並ぶホワイトデー商戦が繰り広げられるのである。

恋愛感情という個人の内面を消費の燃料として組み込み、その派生として生まれた新しい社会的儀礼をさらなる消費の商機とするこの連鎖は、見事に構築された消費主義のシステムである。フジワラは展覧会のタイトルを「ホワイトデー」とすることで、私たちがいまやほとんど無意識に受け止めているシステムの存在に焦点を当てたが、こうした「あたりまえ」を検証する姿勢をフジワラは最初期の作品から持ち続けてきた。自らの生い立ち、家族の歴史を題材に展開する演劇的なインスタレーションは、歴史、しかも自分の歴史というもっとも身近で、他者の立場からは「本人しか知り得ない、もっとも正しいもの」を扱う時点で、鑑賞者に目の前の物語を本能的に信じさせてしまう。しかしそこに交えられた明らかなフィクションは、こうした「正しさ」の前提を覆す切断であり、私たちは無意識に受け止めてきた「あたりまえ」とその根拠を意識せざるを得なくなるのである。これまで信じてきた、あるいは無意識に従ってきたこととは、歴史にしろ制度にしろ構築されたシステムであり、その背後にはさまざまな理由、経緯、ときには思惑が存在することを、フジワラの切断は明らかにする。こうしたフジワラの実践は、ミシェル・フーコーが『知の考古学』で示した歴史への向き合い方、扱い方に参照を見ることができよう。

人々の注意は、逆に、「時代」とか「世紀」として描かれてきた広漠とした単位から、切断の諸現象へと移った。思考の大きな連続性、精神あるいは集団的心性の大量かつ等質的な表明、当初以来熱心に存在しようとし、達成しようとしている科学の堅固な生成などの下に、一つの種類、形式、学問、理論的活動などの存続の下に、いまや人々は、遮断が挿入されていることを検出しようとつとめている。[03]

記録(ドキュマン)への問いかけは、記録が語ろうとしたことを知ろうとしてだけではない。果たして記録が真実を語っているか、なにを根拠にそれが真実だと言えるか？ 記録は誠実なものか、それとも虚偽を伝えるものか？ ［中略］すなわち、それらの記録の言う——ときにはほのめかすだけの——ところから、過去を、記録がそこから発し、今では記録の背後のはるか彼方に消え去った過去を、再構築することである。［中略］歴史が自ら第一の仕事として課するのは、記録を解釈することでも、記録の語る真偽や表現のなんたるかを決定することでもなく、内部から記録に働きかけ、仕上げることなのである。[04]

フジワラの作品が私たちに与えるセンセーションは、フーコーの言う「安定した構造のおかげで出来事の闖入を消し去っているかのようにみえる、いわゆる歴史、ただの歴史」[05] に、フィクション、あるいはフジワラ独特の視点という異物が挿入されることで、この統一が解体される時に生まれる。そして、この解体の引き金が引かれるのは、人間の欲望がシステムの抑圧と衝突する時である。[06] フジワラの作品は、私たちの社会が本質的に安定を旨とし、そのシステムに多少の不都合や疑義があろうとも、それを信じていたいというまたひとつの内なる願いを持っていること——マクベスが、バーナムの森が彼に向かってくるまで彼はけっして滅びることはない、という幻影の予言に、森が立ち上がることなどあり得ない、だから自分は天寿をまっとうし安らかな生涯を送ることができると信じようとしたように——の前に置かれた鏡なのである。この鏡には、システムそのものとそれを信じたい私たちの姿はもとより、それが構築される過程で切り捨てられていったもの、大文字の歴史では語られない個々のエピソードや感情といった、さまざまなものが映し出される。これらの姿は、私たちにある問いを投げかける。なぜ、私たちは普段それを見ようとしないのか、そしてそのシステムは信じられるものなのか、そこに置き忘れたものがありはしないか。システムが合理的に機能しているように思われる時ほど、この問いに向き合うことは重要であり、同時にやっかいである。

フジワラが自らの生い立ちや家族の歴史というきわめて個人的なバックグラウンドを鑑賞者の前に差し出しながら、果敢に、そして欲望にしたがってその問いに向き合おうとする姿勢は、本展のもうひとつの背景と結びつくことで一層力強く響くだろう。東京オペラシティアートギャラリーでは2014年秋に「ザハ・ハディド」展を開催したが、同展は東京が2020年オリンピック・パラリンピック招致に際して行った新国立競技場の国際デザイン・コンクールの最終11案にザハ案が残った時点で企画された。建築雑誌が行った事前の一般投票でも圧倒的な人気を集めたザハ案は、その後最終審査でも最優秀賞に選出され、東京がオリンピック招致に成功する決定的な要因のひとつとなった。[07] しかしこうした華々しいストーリーの背後には、さまざまな問題が置き去りにされていた。都心の一等地である狭い敷地に、8万人を収容する巨大なスタジアム——そのほかにVIP席やスポーツの偉業を伝える資料室、フィットネスセンター、そして巨額の維持費をまかなう目的で行われる音楽イベントのための開閉式屋根、それらすべてを2019年までに整えようとする夢のようなプロジェクトは、次第に現実との齟齬が明らかになっていき、紆余曲折を経て2015年7月、首相による白紙見直しという異例の結末を迎えた。

この一連の出来事は、企画当初に想像した規模をはるかに超えていたものの、日本が抱える問題を露わにするに違いないと予想したとおりの結果となった。ザハ展を開催しなければならないと思ったのとほぼ時を同じくして、サイモン・フジワラ展の企画に着手したことは、必然だったのかもしれない。フジワラの作品が私たちの心を打つのは、合理性という「正しさ」に覆い隠されて見えなくなりがちなものごとの本質を、私たちそれぞれの目で検証することを促し、私たちが見えなかった、あるいは見ようとしなかったことを一瞬で意識させるからである。しかしここで強調したいのは、フジワラの作品はけっしてものごとを「正しい」「正しくない」と規定したり、観る人をどちらかに導くものではないという点である。「ここからあなた自身の姿がよく見えますよ」という切断にフジワラの鮮やかな手腕は発揮されるが、そこでなにが見えるか、どう見えるかに関しては、鑑賞者それぞれが自身と向き合いながら確かめていく自由な余地が設けられている。同じ作品を前にしながら他者とまったく異なる解釈が生まれたり、以前観た時と異なる感想を抱いたりといった幅の広さは、そのままフジワラの作品が許容する多義性、包容力の現れと言えるだろう。

展覧会の準備中、筆者とのやりとりの中で新国立競技場の進捗について話しながら、フジワラは自らの展覧会にこの出来事を反映させる方法を検討した。システムによって愛なく葬られた幻の新国立競技場を、フジワラは彼らしい方法によって作品化し、私たちがそこに自分自身を映し出す機会を創りだそうとしている。そこに映るのは正しい、正しくないの二者択一ではなく、さまざまな文脈の絡み合う社会の複雑さや両義性、システムに回収され得ない人間の欲望や感情、それらをありのままに表しうるアートの力であろう。

本書は展覧会の開催に併せて制作されたが、当初、作家による自作に関するテキストは該当する図版ページにそれぞれ掲載する予定だった。しかし制作の途中で、テキストを後半にまとめて図版ページには文字情報を載せないこととなった。それぞれが独立した作品として機能することで、読者はより一層作品の世界を自由に探索し、その時々の自分の姿を見ることになろう。それは見たい姿ばかりではないかもしれない。毎年3月14日が来るたびに、私はこの本を開こうと思う。そこに映し出されるものは、フジワラから届く愛のこもったホワイトデーのプレゼントなのである。

のむら・しのぶ｜東京オペラシティアートギャラリー・キュレーター

01　ウィリアム・シェイクスピア『マクベス』小田島雄志 訳、白水社、1983年、p.10

02　フェルナンド・ペソア「無人島」2011年東京オペラシティ アートギャラリーにて開催の「project N47 上西エリカ」に際して、福島伸洋により翻訳。

03　ミシェル・フーコー『知の考古学』中村雄二郎 訳、河出書房新社、2006年、p.10

04　前掲書 p.14

05　前掲書 p.13

06　欲望と抑圧の衝突に関するフジワラの分析に関しては、Francesca Boenzi, 'Sexual Architecture,' *Mousse Magazine*, Issue no.20, September 2009, http://moussemagazine.it/articolo.mm?id=460 に詳しい。

07　「読者イチ押しは『ザハ』予想は『SANAA』、新国立コンペ」、ケンプラッツ、日経BP社、2012年11月7日、日本経済新聞社電子版 2012年11月9日 http://www.nikkei.com/article/DGXNASFK0903P_Z01C12A1000000/

Simon Fujiwara's Mirror on Us
Shino Nomura

Fair is foul, and foul is fair:
Hover through the fog and filthy air.

From *Macbeth*, act 1, scene 1
William Shakespeare |01

My window lies towards the mist
And the mist is all, and the universe in half. —
If I search for myself, in my eyes I read it
The virtual time and on me I lift it.
…
Ah, the desert island, in sea, at the bottom
Of my consciousness!
And among us the imprecision of the world.

From *The Desert Island*
Fernando Pessoa |02

The title *White Day* arose early in our preparations for Simon Fujiwara's first solo museum show in his Japanese homeland. Fujiwara regarded the exhibition as an opportunity to position his work in the context of a system of social paradoxes. People devise systems and frameworks to bring order, direction, and norms to the breadth of human diversity—structures that afford a continuous basis for thought and action in every social setting. Fujiwara expressed a special interest in Japan's White Day tradition, which requites the Japanese inversion of Valentine's Day: Females give chocolates to males on Valentine's Day, and males reciprocate with gifts a month later.

White Day is the culmination of a quintessential mechanism of the system of consumerism. It culminates a chain of contrivances that begins with the sublimation of repressed romantic desire into consumption, that continues with derivative consumption unrelated to romantic feelings, and that segues into consumption born of reciprocal giving on the day in question.

Valentine's Day took hold in Japan as the nation's confectionery industry imported the tradition from the West in the 20th century and propagated it locally for commercial gain. Something got lost in translation, however, and the Japanese assimilated Valentine's Day as an occasion for females to give chocolates to males.

Japanese social mores long discouraged women from displaying their affection openly towards male counterparts. Valentine's Day became a socially acceptable vehicle for skirting that taboo. And by the late 1970s, females of all ages throughout Japan were sublimating passion through chocolate gifts on February 14.

Of special interest in the Japanese version of Valentine's Day is the phenomenon of *girichoko*, or 'obligatory (*giri*) chocolates (*choko*)'. *Girichoko* is the product of a commercial stratagem that has successfully tapped ingrained Japanese notions of etiquette. Females give *girichoko* to males in their lives, such as classmates, co-workers, and customers, towards whom they have no romantic interest but towards whom they harbour goodwill. The chocolates are far smaller and fewer, of course, than those destined for objects of romantic affection.

Japanese possess a cultural instinct for reciprocating gifts received with further gifts, and Japanese confectioners and other companies have capitalised handsomely on that instinct with White Day. The 'tradition' of males reciprocating their Valentine's Day haul with gifts to the female donors on March 14 is a commercial creation. Come March, stores and shops throughout the land are awash with candies, handkerchiefs, jewellery, and other items arrayed especially for White Day giving.

Fujiwara, in an approach that dates from his earliest work, probes the essence of social constructs commonly taken for granted. His installations unfold through complex and destabilising narratives that frequently draw on his personal background and family history. Fujiwara's richly textured works ensnare the viewer in a labyrinth of facts and anecdotes whose truths are known only to the teller.

The artist's embrace of subjectivity and all the inconsistencies that it entails obliges us to deal consciously with phenomena that we had accepted or at least tacitly sublimated to function within our network of social systems. It reveals history and social practices as human constructs and illuminates the reasons for those constructs, the course of their evolution, and the expectations that they subsume. Fujiwara thus comes to terms with history in the manner described by Michel Foucault in his introduction to *The Archaeology of Knowledge*.

> Attention has been turned, on the contrary, away from vast unities like 'periods' or 'centuries' to the phenomena of rupture, of discontinuity. Beneath the great continuities of thought, beneath the solid, homogeneous manifestations of a single mind or of a collective mentality, beneath the stubborn development of a science striving to exist and to reach completion at the very outset, beneath the persistence of a particular genre, form, discipline, or theoretical activity, one is now trying to detect the incidence of interruptions. … Documents have given rise to questions; scholars have asked not only what these documents meant, but also whether they were telling the truth, and by what right they could claim to be doing so, whether they were sincere or deliberately misleading… the reconstitution, on the basis of what the documents say, and sometimes merely hint at, of the past from which they emanate and which has now disappeared far behind them… history has altered its position in relation to the document: it has taken as its primary task, not the interpretation of the document, nor the attempt to decide whether it is telling the truth of what is its expressive value, but to work on it from within and to develop it. |03

'History itself appears to be abandoning the irruption of events', Foucault writes in *The Archae-*

ology of Knowledge, 'in favour of stable structures'.[04] The sensations that one experiences through Fujiwara's work arise while the fictions and subjectivities interspersed through the works demolish our sense of stability.[05]

Fujiwara places a mirror before our eyes. He directs our gaze to how we have predicated our ideal of society on stability and to how we have countenanced the occasional drawbacks of the systems adopted to ensure that stability. We encounter in his mirror our inherent longing for reassurance—the same reassurance, perhaps, that Macbeth believes that he has obtained through his encounter with the Apparitions. The Third Apparition assures him that 'Macbeth shall never vanquish'd be/until Great Birnam wood to high Dunsinane hill/shall come against him'. And he interprets that as a guarantee that he 'shall live the lease of nature, pay his breath/to time and mortal custom'.[06]

Our gaze, as directed by Fujiwara's mirror, turns to the systems that we inhabit, to our determined belief in those systems, to the sacrifices rendered in the construction of the systems, and to the episodes and emotions unaccounted for in History with a capital 'H'. Fujiwara invites us to 'reflect' on why we decline in daily life to perceive the systems in question, on whether the systems warrant our belief, on whether we haven't missed something important. Viewing the systems is all the more difficult when they are ostensibly functioning normally, yet that is precisely when perceiving the systems accurately is most crucial. The issue of hidden systemic defects provided a layer of coincidental yet striking background for this exhibition.

As the planning of this exhibition began, we at the museum were amidst the planning of another exhibition: an overview of the oeuvre of the London-based architect Zaha Hadid, whose design for Japan's new national stadium would become the subject of a fiasco of historic magnitude. The winning design would be a central element in Japan's bid to host the 2020 Olympic and Paralympic Games. Hadid's proposal had received overwhelming approval in a poll by a prominent online architectural website in Japan. It would prevail in the final selection by a panel of leading architects.[07] And Japan's Olympic bid, fortified with Hadid's stadium design, would prove victorious.

Alas, the Hadid-designed stadium was not to be. What unfolded was a tragicomic farce imbued with plot lines redolent of Fujiwara's take on society and its internal contradictions. The selection process had glossed over several fatal flaws in the planning of the stadium. To begin with, the 80,000-spectator-capacity size specified for the facility by the Japan Sport Council was incompatible with the central-Tokyo site. The Japanese, moreover, wanted the stadium completed in time for the 2019 Rugby World Cup, which will also take place in Japan. But their selection contained a number of features that were utterly unrealistic in view of their budget and deadline: a retractable roof—essential for the music concert revenues necessary to offset the stadium's running costs; a fitness centre; a high-tech sports archive; and luxurious accommodations for VIP seating. The project's abject unfeasibility ultimately became impossible to ignore, and Japan's prime minister, Shinzo Abe, took the all but unprecedented step of calling for a new design in July 2015.

We couldn't have imagined the humiliating outcome, of course, when we planned the Zaha Hadid exhibition at the Tokyo Opera City Art Gallery. But I could see even then that the design proposal would expose systemic deficiencies in Japan. I discussed the national stadium debacle with Fujiwara during the preparations for his exhibition, and he expressed an interest in reflecting it in his exhibition. Fujiwara delights in such collisions of high-concept ideals with the procedural shortcomings of human endeavour. He takes great pleasure in events as seemingly loveless as the abortion of Hadid's fantasy stadium. And he creates through his work opportunities to examine the relevance of the episodes—more from the vantage of poetry than of social science. What registers with us most forcefully in Fujiwara's work is the artist's urging to look beyond the alleged truth of rationality, to perceive the frequently obscured essence of things, and to determine, even, if such an essence exists.

Moral and technical delineations of 'correct' and 'incorrect' are of no interest to Fujiwara, and he is equally uninterested in steering the viewer in either direction. Whilst the mirror that he places before us is murky with ambiguities and inconsistencies, he leaves to us the pleasurable task of deciding what is on view in the mirror and how it is to be perceived.

Fujiwara's works are marvels of inclusiveness. They allow and even encourage different viewers to come away with different impressions and the same viewer to come away with different impressions on repeated viewings. Here is the power of art: the power to transcend simplistic binary choices between 'right' and 'wrong', to accept the contextual complexities of human society, and to express on a case-by-case basis the human desire and emotion that lie beyond the pale of any system.

As I grow and age in the years ahead, I will gain a deeper understanding of myself. I will return to this catalogue annually on March 14 and will find each year a different reflection of myself inside. Whatever I might think of that reflection, it will be my White Day gift from Fujiwara.

Shino Nomura | Curator, Tokyo Opera City Art Gallery

01 William Shakespeare, act 1, scene 1, *Macbeth*, Routledge, 1992, p. 4

02 Fernando Pessoa, *The Desert Island*, translated by Erica Kaminishi on the occasion of an exhibition *project N 47 KAMINISHI Erica* at Tokyo Opera City Art Gallery, 2011

03 Michel Foucault, *The Archaeology of Knowledge*, Routledge, 2002, pp. 4–7

04 ibid. p.6

05 Francesca Boenzi, Sexual Architecture, *Mousse Magazine*, September 2009, moussemagazine.it/articolo.mm?id=460

06 William Shakespeare, act 4, scene 1, *Macbeth*, Routledge, 1992, pp. 112–113

07 Dokusha ichioshi ha Zaha, yosou ha SANAA, Shinkokuritsu kompe (Reader's Favourite: Zaha, Likely Winner: SANAA, New National Stadium Competition), 7 November 2012, *Kenplatz*, http://www.nikkei.com/article/DGXNASFK0903P_Z01C12A1000000/

フジワラの芸術的効果
クリストファー・グレイゼック

サイモン・フジワラの誕生に2年先立つ1980年、アメリカ精神医学会は『精神障害の診断と統計マニュアル』に心的外傷後ストレス障害を追加し、ここからトラウマ理論と西欧文化の10年に渡るロマンスが始まった。ミレニアル世代（1980年前後から2005年にかけて生まれた世代／新世紀世代）はとりわけトラウマに悩む世代ではないかもしれないが、わたしたちはともすれば歴史を暴力的で傷痕を残すものと考えがちなうえ、合理性から外れるものにはすぐにトラウマをもちだして説明をつけようとする点で、「トラウマの世代」であるにちがいない。

トラウマとの縁をみる限り、フジワラはさほどミレニアル世代らしくもない。自分自身の過去にとっぷりと浸かりはしても、本人は珍しくそれを重荷と感じないようだ。トラウマ理論の重鎮キャシー・カルースによると、トラウマには原因となる出来事があり、その反応が「しきりに割り込む幻覚、夢、思考、振る舞い」として現れる。トラウマはしばしば「痺れ」を伴い、「出来事を思い出させる刺激に対する過剰な興奮（あるいは刺激の回避）」が付随することもある。フジワラの作品はしばしば原因となる出来事を儀式のように再現し、秘めた履歴を掘り起こすけれども、トラウマを構造化と説明付与の原理にはしない。トラウマをひとまず脇におき、フジワラは人間体験の複雑さ、非合理性を信頼して、それとは異なる考え方、感じ方を探ろうとする。

フジワラが物語やとりとめのない主張を探り——そのリズムのもつ魅力（大団円の歓び、観念的な把握の悦び）の恩恵に授かり——ながら、演劇、映画、ドキュメンタリーや人気上昇中のTEDのようなひとの欲求におもねる饒舌に耽ることなく、知性を心地よく刺激する「芸術的効果」を失わないのは、並外れた手柄にちがいない。語り手はいつも頼りない——作品に現れる物語の中には真実もあるが、作り話もある——けれども、ハリウッド式の味気ない「すべては夢でありました」では決して終わらない。フジワラのよく知られた作品の大半——《ミラー・ステージ》(2009-2013)、《再会のための予行演習》(2011-2013)、《スタジオ・ピエタ》(2013)——は作者本人の過去を掘り起こすが、それはアイデンティティの謎を解くためではなく、物語と記憶が作品の形態に強いる制約、護符や呪物の関わり、演劇、パフォーマンス・アートと批評を隔てるあやふやな境界を探る口実に用いられる。

《ミラー・ステージ》でフジワラは子役（鑑賞者の代役）に、真偽のほどは疑わしいある物語の意義を学者ぶって解きあかす。そこでは11歳のフジワラがテート・セントアイヴス（世界の文化との唯一の接点だったと告白する）を訪れ、抽象絵画に見入り（この図柄は後にIKEAが無断借用しベッドシーツとして販売した）、勃起し（キャンバスを突っついたそうである）、自分は画家になる運命にあると思いなし（もっともその後、美術学校在学中に絵を放棄する）、逸脱した性の嗜好の持ち主と直感する（自分が秘密を持っていることは自覚しているが、それがどんな秘密かはわかっていない）。《テオ・グリュンベルクの私的な財産》(2010)のように自伝的要素を含まないパフォーマンスでも、フジワラは同様の手順を踏む。この作品はフジワラの『アウステルリッツ』風の試み、つまりテオ・グリュンベルクという同姓同名の3人の男の過去の再構築に取材した講演の形をとる。そして《ハロー》(2015)では、メキシコ人のごみ拾いとドイツ人CGアニメーターがカメラの前でそれぞれの人生を告白し、気紛れな幸福を値踏みする姿を描く。

物語、好奇心の昂進、説明をつけたり撤回したりして得られる満足感を手順毎に整理して、フジワラの作品は理論に飽いた同輩がしばしば意図的に排除する「知的」快楽の中枢を刺激し、増進させる。フジワラの作品が蓄える電気の種類を特定するのは難しい——多様なせいもある——が、魔法のような魅力の一部は、逆説のエネルギーを、物語の工具一式の中の役立つ道具としてではなく、オブジェクトやテキスト、伝記風の展示、パフォーマンスに精気を吹き込む美術表現の大きな枠組として方向づけ、これらの要素をひとつに融合させて理解しやすくまとめるところにある。こうした方法をとろうとすれば、作者は常に逆説に好奇心を抱くと共に、逆説が責めを負わせられることの多い観念、感情の激発に対して、並々ならぬ許容力を保持しなければならない。

たとえば《ハロー》は、まさに感情と知性のズレによって鑑賞者を面食らわせる。わたしたちは登場人物について、かれらの語る人生について、どう感じるように期待されているのだろうか。マリア・マルティネスの語るごみ拾いの暮らしを聞いて、わたしたちは、見るものを動揺させる類のインタヴュー場面の映像により倫理の破綻を印象づけるドキュメンタリーを見たときのように、当惑すればよいのだろうか。言い換えれば、わたしたちはマルティネスの貧困にうろたえ、切断された手を発見したと聞いてショックを受け、他人——覚醒剤の売人につづいて企業の慈善事業——の都合に振り回されても朗らかで心穏やかなのに驚けばよいのか。それとも——ひょっとするとそれと同時に——マルティネが幸福でいることに敬服し、彼女の忍耐力、カリスマ、品格に驚嘆したほうがよいのか。そうではなく、マルティネスに話をさせたのは悪の凡庸さ、人間の暮らしは文化や階級、職業がちがっても基本的に同じと思わせたかったのかもしれない。マルティネスのピンクのTシャツに記された、「愉快な職場」の伝えるメッセージはそれなのか。ゴミ集積場はふつうなら職場と見なされないだろうが、映像はどうやらわたしたちにゴミ拾いでもCGアニメーターでも、工場労働者でも美術作品捏造者でもだれでも、手を動かして金を稼ぐ限り、本当のちがいなどないと思わせようとしているようだ。真の職場はゴミ集積場ではなく、慈善事業の触れ込みで企業が建設したリハビリ専門クリニックなのかもしれない。台座に彫刻のように載せられ、清潔なスタジオ——真っ白い壁に囲まれ無数のベッドやキャビネットが並ぶクリニックにそっくりの道具立て——の中空に浮かび、マル

ティネスはアーティストにリハビリを施され、世界中の美術館に展示される紛れもない美術作品として立ち直る。さて、それではフジワラ自身は何なのだろうか。ゴミ拾いの仲間入りすることになるのか。それより企業から派遣されたリハビリ施設の所長のほうがお似合いか。ゴミ集積場に足を運び、労働者を面接し、かれらのために小さな温泉でも作ってやるか。それともアーティストと本当に血の繋がっているのは、ゴミ拾いを奴隷化してぼろ儲けを図る覚醒剤の売人という暗澹とした可能性も否定できない。

無論、マルティネスは実在せず、実はCG映像かもしれないと暗示する手がかりもある。もしそうなら、彼女はアーティストの想像力が産んだ虚構なのか、それともドイツ人アニメーターのマックスの思考の産物なのか。マックスは生まれつき両手がないか、それとも事故で失ったらしく、果てしない旅空の下の暮らしと、すべては自分の思う儘の自由自在さを求めて自営のデザイン事務所を閉鎖したところだという。ヴィデオの中程でイージーリスニング音楽が聞こえ始めて広告の世界を連想させ、CG映像の手がいとも無頓着に画面をスクロールして、情景と登場人物を気儘に切り分けることまで考えに入れると、さらに意味の層が加わってくる。舞台裏で仕事に励む広告デザイナーがいて、素材の結合が終われば、新しい自己啓発運動か人類の滅亡を信じるカルト集団の30秒のコマーシャル・ヴィデオが出来上がるのかもしれず、わたしたちはその現場を目の当たりにしているとも考えられる。

こうした質問はどれも避けがたく、まただれもそれを避けたいとは思わないだろう。作者自身も同感で、もともとややこしさを面白がる質である。アーティストは昔から鑑賞者に視覚、聴覚、あるいは思考の合図を送る手法を用いてきた。フジワラがその中で際立つのは、第一に鑑賞者を実に楽しそうに観念のウサギの穴に押し込むこと、第二に多種多様な逆説を同時に見つめ、考えることから強烈な美的体験を引き出す点にあり、しかもその逆説は作品の形式や審美性にとどまらず政治、倫理、哲学的な課題にまでおよんで、いっそう深みを増す。フジワラの作品では、ひとを惑わせるのは特権とされる。感覚を疲弊させたり、手垢のついた知ったか振りで辟易させたり、知力を当惑させ混乱に陥れるのではなく、フジワラの作品は鑑賞者が頭を使い深く思考する地ならしをする。シミひとつない卵を並べるのではなく、フジワラは果皮がいくつも層をなすタマネギを生産する。フジワラの作品を鑑賞する立場にある者として、わたしたちはその層を剥きながら、泣いたりせずに、人間の歴史の謎を選り分けてゆくように求められる。

フジワラは度を越した刺激に耽ることを目指しているのではなく、刺激を大いに楽しみ、余分なものをつけ加えずに、鑑賞者を混じり気のない、ほとんど子供のような好奇心に引き寄せて、美術をより広範な知識の探求の一部に位置づける。フジワラの提案は「大問題」と取り組ませて美術界の営為を強化する一方、そうした問題を映像、調和、パフォーマンス、深い感動を呼ぶ美の力に敏感なアーティストの感覚をもって探る点で、二重の利益をもたらす。

ミレニアル世代は集団として性的少数派の権利、インスタグラム、グルテン抜きの美食を世界にもたらした。それから冒頭に「あなたの気分を著しく害する可能性のあるコンテンツを含みます」と警告する習慣も、わたしたちの世代の贈り物だった。フジワラも当然ながら同世代の仲間が見つめるプールの水を試してみた。過程、視点の歪曲、またミクストメディアの拓く可能性に魅了され、フジワラは自動筆記、美術館や画廊の役割を批判的にただすアート、デジタル・アニメーション、抽象絵画にも手を初めた。フジワラの作品の背景をなす都市――ベルリン、上海、メキシコシティ、テルアビブ――もまた、ミレニアル世代の想像力に大きな影をおとす、若々しい遊牧民たちの主要な目的地に他ならない。フジワラの作品から発生するオーラ――フジワラの「芸術的効果」――は、ただしミレニアル世代の耳に馴染んだ周波数より広い範囲で作用する。

アーティストが物語を退け、他の形で関与することによって隣接分野との差別化を図ることが多かったため、美術界はトラウマを抱えた人々に自然の避難場を提供することになった。フジワラの作品を「精神疾患なし」と呼んでも、運動の中心におくことにはならないだろうが、現代のわだかまりから解放され、感覚の実験に踏み込む用意を調えた作品制作の場を提起することにはなりそうだ。フジワラの器用な手のおかげで、わたしたちはこれまで決して自分から触ろうとしなかった物に手を触れるのである。

クリストファー・グレイゼック | ライター/編集者

Fujiwara's Art Effect
Christopher Glazek

In 1980, two years before Simon Fujiwara was born, the American Psychiatric Association added post-traumatic stress disorder to its Diagnostic and Statistical Manual, setting into motion a decades-long romance between trauma theory and Western culture. Millennials may not be an especially traumatized generation, but we are the "trauma generation" to the extent that we've been conditioned to think of narrative as violent and scarring, and to depend on trauma as an explanation of first resort for anything outside the rational.

When it comes to trauma, Fujiwara is not much of a millennial. Despite immersing himself in his own past, he seems almost uniquely unburdened by it. As it's defined by Cathy Caruth, the dean of trauma theorists, trauma is a response to an event that "takes the form of repeated, intrusive hallucinations, dreams, thoughts, or behaviors stemming from the event." Trauma is often accompanied by "numbing," and sometimes also by "increased arousal to (or avoidance of) stimuli recalling the event." Fujiwara's work often ritually reenacts seminal events and unearths secret histories, but it rejects trauma as a structuring or explanatory principle. Putting trauma aside, Fujiwara allows himself to investigate other modes of thinking and feeling, crediting the complexity and irrationality of human experience.

Fujiwara's unusual achievement is to explore narrative and discursive argument—and to benefit from their rhythmic appeal (the pleasure of dénouement, the joy of conceptual recognition)—while maintaining an "art effect" that massages the intellect without yielding to the appetitive glibness of theater, cinema, or documentary, or newer popular forms such as the TED Talk. While his narrators are always unreliable — some of the stories that appear in his oeuvre seem to be true, others to be fabrications — the payoff is never Hollywood's texture-less "it was all a dream." Much of Fujiwara's best-known work, for instance *The Mirror Stage* (2009–2013), *Rehearsal for a Reunion* (2011–2013), and *Studio Pietà* (2013) mines the artist's past, not to solve the riddle of identity, but as a pretext to investigate the formal constraints of narrative and memory, their relationship to talismans and fetish objects, and the unstable boundaries between theater, performance art, and criticism.

In *The Mirror Stage*, Fujiwara donnishly decodes for a novice actor (a stand-in for the viewer) the significance of a story, possibly apocryphal, in which the eleven-year-old Fujiwara visits Tate St. Ives (his only access point to global culture, he avows), stares at an abstract painting (a design later pirated by Ikea and sold in the form of bedsheets), gets an erection (which allegedly pokes into the canvas), determines his destiny is to become a painter (though he later abandons the medium in college), and intuits that he's a sexual deviant (he knows he has a secret, but he doesn't know what the secret is). Fujiwara uses similar procedures in non-biographical performances such as *The Personal Effects of Theo Grünberg* (2010), which takes the form of a lecture on Fujiwara's *Austerlitz*-like quest to reconstruct the histories of three different men named Theo Grünberg, and *Hello* (2015), in which a Mexican trash picker and a German computer animator confess their life stories and assess the vagaries of happiness before a camera.

In thematizing the procedures of narrative, the lust of curiosity, and the satisfaction taken in issuing and retracting explanation, Fujiwara's art stimulates "intellectual" pleasure centers often deliberately excluded by his theory-weary peers. The types of electricity in Fujiwara's work are difficult to pinpoint — in part because they are diverse — but a large part of the Fujiwara spell, I'd suggest, comes from channeling the energy of paradox, not as a subservient device in the narrative toolkit, but as an overarching aesthetic framework that breathes life into physical objects, pieces of language, biographical exposition, and real-time performance, and fuses these elements together into an apprehensible whole. It's a system that requires him to be unceasingly curious about paradox, and also, it might be said, unusually resilient in the face of the conceptual and emotional violence for which paradox is often blamed.

Hello, for example, confounds the viewer on precisely the levels of emotional and intellectual paradox. How are we supposed to feel about these characters and their life stories? Is Maria Martinez's testimony about her life as a trash picker supposed to vex us in the way that documentaries often use unsettling footage from interviews to draw attention to a moral catastrophe? In other words, are we supposed to be dismayed by Martinez's poverty, shocked by her tale of discovering a severed hand, and bewildered by her mirthful equanimity in the face of her life's takeover — first by meth traffickers and then by corporate philanthropists? Or instead, perhaps at the same time, are we meant to admire her happiness and marvel at her perseverance, charisma, and style? Alternatively, perhaps the point of her story is to cause us to ponder the banality of evil and the fundamental similarity of the human condition across cultures, classes, and occupations. Is that the message delivered by Martinez's pink T-shirt, which reads "Atelier Lovely"? While a trash dump is not ordinarily thought of as an atelier, the film seems to require us to consider whether there's any real difference between a trash picker, a computer animator, a factory worker, an art fabricator, or anyone else who earns money by laboring with their hands. Perhaps the real atelier isn't the trash dump, but rather the rehab clinic installed there by the corporation, purportedly in the service of philanthropy? Seated sculpturally on a plinth and floating in a pristine studio — a setting that would seem to mirror the clinic with its white walls and abundant beds and drawers — Martinez is "rehabilitated" by the artist and recuperated as a literal, physical artwork that Fujiwara will exhibit in museums all over the world. And what, then, about Fujiwara himself? Is that artist to be slotted among the ranks of trash-picking laborers? Or is he more like the corporation's rehab clinic director, who visits the trash heap, interviews the laborers, and

builds them a mini spa? What about the darker possibility that the artist's true kinship is with the meth trafficker, who enslaves the trash pickers for his own lucrative ends?

Other cues suggest that Martinez isn't real at all — that she actually might be a computer-generated image. If so, is she a figment of the artist's imagination, or the brainchild of the German animator, Max, who seems either to have been born with no hands or to have lost them in an accident, and who has decided to shut down his design agency in order to pursue a life of infinite travel and I-did-it-my-way flexibility? Extra layers are added once we consider the easy-listening music that intercedes midway through the video, evoking the world of advertising, as well as the dismembered CGI hand, which nonchalantly scrolls through images, splicing scenes and characters at its own will. Perhaps we're witnessing an ad designer working behind the scenes, suturing together material that will eventually be cut into a thirty-second commercial for a new self-help movement or doomsday cult?

All of these lines of questioning are unavoidable, and who would want to avoid them, anyway? Not Fujiwara, who delights in such complexity. Confronting the viewer with a multifarious array of visual, aural, and conceptual cues is a traditional strategy for an artist. What makes Fujiwara distinct is firstly the joy he takes in pushing the viewer down these conceptual rabbit holes, and secondly the aesthetic power he draws from the simultaneous contemplation of so many separate paradoxes — paradoxes that are all the deeper for taking up political, moral, and philosophical questions in addition to formal and aesthetic ones. In Fujiwara's work, puzzling is a privilege: instead of inducing feelings of sensory exhaustion, jaded knowingness, or psychic discombobulation, the work primes viewers for intellectual contemplation. Instead of laying immaculate eggs, Fujiwara produces multilayered onions; as his viewers, we're meant to peel back the layers without crying, cheerfully sorting through the riddles of human history.

Fujiwara's goal is not to revel in overstimulation; it's to revel in stimulation *tout court*, and to pull viewers toward a pure, almost childlike curiosity. In doing so, Fujiwara asserts the position of art within a broader tradition of intellectual inquiry. His overture has a dual benefit: it simultaneously fortifies art-world discourse by enjoining it to address the "big questions," and ennobles those questions by exploring them with an artist's sense for image, proportion, performance, and aesthetic electricity.

Millennials have gifted the world with trans rights, Instagram, and gluten-free gastronomy; we've also given birth to the trigger warning. Inevitably, Fujiwara has dipped into many of the same pools as his generational peers. Fascinated by process, distortions of perspective, and the possibilities unleashed by mixed media, he has dabbled in automatic art, institutional critique, digital animation, and abstract painting. Even the cities that star as backdrops for his work — Berlin, Shanghai, Mexico City, Tel Aviv —are major destinations for the youthful nomads who loom large in the millennial imagination. The aura generated by Fujiwara's work, though —his "art effect"— operates on a wider range of frequencies than millennials are accustomed to hearing.

To the extent that visual artists often distinguish themselves from adjacent fields by rejecting narrative in favor of alternative formal interventions, the art world has provided a natural haven for traumatics. To call Fujiwara's art "well-adjusted" doesn't do much to locate it at the center of a movement, but it does propose a plane of aesthetic inquiry liberated from contemporary hang-ups and primed for sensory experimentation. In Fujiwara's capable hands, we get to feel things we've never allowed ourselves to feel.

Christopher Glazek | Writer / Editor

幸福の経済学
ダニエル・フジワラ

英国人についてわたしたちは今、これまでにないほど多くのことを知っている。クレジットカード会社やスーパーマーケット、インターネット上で事業を営む企業、そしてグーグルなどのウェブサイトが、わたしたちの日々の暮らしについて収集する情報は厖大な量に上る。そればかりではない。英国では、ひとの好きな食べ物や信用格付け、休暇の過ごし方などよりもはるかに重要な事柄についても、より多くがわかっている。なぜなら英国は他国に比べ、ひとの幸福についてより多くのデータを収集しているからである。幸福とは、おおまかにいって個人の生活の全般的な質の高さ、快適な暮らしを意味する。こうした面での豊富なデータは公的機関、研究機関、政府の政策立案者が、英国社会の進歩の状況を評価し理解する方法に変化をもたらし、また英国の経済学者には政策の立案、査定について理解を深める絶好の機会を提供した。

多くの哲学者と経済学者の大半は「福祉国家主義的」に世界を見る。つまり、わたしたちにとっては福祉と快適な暮らしが大切で、満足のゆく生活以上に重要なものは何もないと考える。わたしたちが尊ぶものは健康、家族、子供たちの教育、仕事、環境など様々にあるが、つまるところそれらは幸福をもたらすからこそ重要なのである。健康や教育がわたしたちにとって「手段として」価値がある(ある目的のための手段)のに対して、快適な暮らしは究極的な「固有の価値」(わたしたちが努力する目標)である。快適な暮らしがひとにとって「固有の善」ならば、幸福に関するデータはわたしたちの行動が倫理的な意味合いで、ひとや社会にとって「良い」ことか悪いことかを評価するのに役立つ。個人であれ政府であれ、自らの行動が人々の暮らしをより快適にするか否かを査定することが可能になる。そして最終的には、このデータを利用して、わたしたちは自分自身にとっても社会にとっても、より良い選択をすることができる。

これは何も新しい考え方ではない。幸福に興味を抱いたひとは古代ギリシアのアリストテレスやエピクロスをはじめとして数多く、かれらは「良い暮らし」は何から成り立つのか、そして幸福をどう定義すればよいか、熱心に考えを巡らした。中世こそ快適な暮らしはややないがしろにされたものの、18世紀の英国に力強く復活し、ジェレミー・ベンサムが政府の政策決定に幸福の度合いを勘案する総合的、体系的な枠組み作りにはじめて取り組んだ。ベンサムは国民の苦痛を減らし快楽(幸福)を最大化するよう政府に求め、これに功利主義の名がついた。この理論には、しかし快楽と苦痛を確実に測定するのが難しいという問題がつきまとう。

過去百年ほどの経済学者は暮らしの快適さを消費面の充足度によって測ってきた。物質的な欲求が満たされれば、それだけ暮らしは良くなると考えたのである。[01]これを経済学では「効用」と呼ぶ。これによるとひとが何を選ぶかによって暮らしの快適さの度合いを測れるから、評価が容易になる。通常は所得が多ければ欲望を満たしやすくなるため、所得と国民一人当たりの国内総生産が、経済学者にとっては、個人の暮らしの快適さの度合いを測る基準になる。このため英国では過去数十年に渡り、多くのひとの指摘によればサッチャー時代を皮切りに、公共政策を論ずる際には国内総生産と国民所得を巡る論議が多く交わされるようになった。

しかし今や新時代の幕開けを迎えようとしている。心理学者や社会科学の研究者たちがいわゆる主観的幸福度(SWB)に関する質問事項についてじかに人々の感想を問い(自分自身が暮らしの良し悪しをどう思うか尋ねる)、幸福の度合いを測定し、数値化する方法を開発した。SWBの判定は広範な心理測定法と統計的検定により、有効性が実証されている。経済運営や政策決定にも関わるSWBへの興味は、新たなデータが利用可能になり、消費者としての選択や所得の多寡はひとの幸福の度合いを測る尺度として有効でない(後に詳しく述べる)ことを示す行動経済学(主導したのは主として英米の研究者)の文献資料が充実してきたため、一段と加速した。幸福の経済学はしたがって新しい考え方でもなければ、研究分野でもない。新しいのは何かといえば、それは幸福の度合いを信頼性高く、大規模に測定する能力である。

英国は国際舞台でこの動向の先端を走っている。2010年にキャメロン首相は「国の進歩の度合いを、経済がどれほど成長しているかだけでなく暮らしがどのように改善されているか、生活水準ばかりでなく生活の質によって測定する作業に着手」しようとして、国家幸福プログラムを発足させた。毎年数十万の英国人が、今どのように感じているか、そして生活全般についてどう感じるかとの質問を受ける。このデータは全国調査によって収集され、最近ではインターネットやスマートフォン・アプリの利用も増している。こうした調査では人生に対する満足度(「このところ人生全般にどれくらい満足していますか?」)と刹那の幸福感(「今、この時点でどれくらい幸せですか?」)を問うのが一般的で、返答は通常0-10または1-7の尺度で判定される。短い質問によってひとの暮らしの良し悪しの全体像が明らかになるかとの懸念ももっともだが、この方法がかなり有効であることはすでに証明されている。たとえば健康や自殺率(このふたつが幸福感と緊密に関連することは直感的に理解できるだろう)との相関性が高く、実験室の研究でも回答が快楽や幸福を感じる脳の部分の活動と関連することが明らかになった。[02]

SWBのデータの魅力は、人生に起こる出来事や生活環境などじつに広汎な事項に関わるデータと同時に収集されるため、多様な事象や状況が幸福におよぼす影響の度合いも測定できるところにある。たとえば幸福に関する公刊資料によると雇用は幸福を増進し、人づきあいも重要、健康はきわめて重要なのに比べ、公害や環境悪化、政治腐敗、貧困は悪影響をおよぼす。これは経済学者にとっては大いに注目に値するもので、雇用、健康、教育など政策の影響がデータ化さ

れている分野では、各要因（しばしば多額の公費が注入される）が人々の暮らしの質におよぼす影響を観察することができる。SWBを用いる経済学者の数は増す一方で、「幸福の経済学者」と名称さえ定まった。また英国の大学は多くの点でこの分野の研究を主導しており、「幸福の経済学者」として職を得ている研究者も多ければ、これを主題とする大学の講座の数も増加しつつある。ノーベル経済学賞を受賞したダニエル・カーネマンによれば、経済学は「ベンサムに立ち戻ろう」としている。[03] つまり、国内総生産のような旧来の指標に代わり、ベンサムが他に先駆けて提唱した直接個人に注目する幸福の指標が採用されつつある。

英国には公共政策の決定に際し、快適な暮らしに配慮する長い歴史がある。ベンサムの先駆的な試みはジョン・スチュアート・ミルなど後に続く功利主義者の手でより充実したものとなった。幸福に関するデータを政策に反映させる動向の先頭を行くのが、他に先駆けてその手法を概念化した国であるのは、当然ともいえるだろう。功利主義を掲げた英国の先達が、幸福に関するデータを充実させる上で英国を世界の指導的な地位に押し上げる基礎を固めたともいえるだろう。今やその重要性は政治姿勢の如何を問わず、広範に認められているように思われる。

幸福関連データが政策の決定に寄与し、洞察を深める上で果たす重要な役割はふたつある。ひとつはわたしたちの暮らしにとって重要な事柄に新たな光を投じること。人々の消費と所得にばかり気を取られると、多くの細かな事情を見逃すことになる。たとえば世界を国内総生産の視点から見ると、雇用の価値は個人の所得増加としてのみ評価され、ボランティア活動は、慈善団体が無償で提供を受けなかった場合にその労力に対して支払わなければならなかったであろう金額として算定される。ところが英国の幸福関連データによれば、雇用は賃金の取得という利点をはるかに越えて、ひとの幸福に好影響をおよぼす（主に自負心、達成感、そして社会の有用な一員であるという満足感）。[04] またボランティア自身も幸福感が増すと感じることも調査から明らかになった（自負心の高まり、ひとの役に立つと感じる心の温もり）。[05] 幸福に関するデータは、雇用とボランティア活動が英国人にとって、これまで考えられてきたよりもはるかに重要であることを示している。もうひとつ例を挙げれば、人々の比較考量にばかり目を向けると、だれでも住まいの近くに発電用の風車が建つのは避けようとするし、身体の健康を心の健康よりはるかに重視するように見えてくる。ところが幸福に関するデータを見ると、住まいのそばに風車ができると実際には幸福感が増し[06]（環境に配慮している自分を誇らしく思うのだろうか）、心の健康の方が肉体の健康よりもひとの幸福に大きな影響をおよぼすことがわかる。[07]

何を欲するか訊ねられると、ひとは状況変化への自らの適応力を過少評価するのが理由の一端だろうか。ひとは発電用の風車にかなり迅速に適応し、風車は良いものと考えるようになる。またひとにとっては精神よりも肉体の健康状態の変化の方が、障害の大小にかかわらず、適応しやすい。自分は何を欲し、どう感じるかというひとの考えは、幸福を測るにはなはだ不出来な尺度でしかない。その点、幸福関連データは、人々が様々な出来事や状況に実際にどう対応したかを教えてくれる。

次に、幸福に関するデータを利用することによって、健康増進や犯罪率の低下など、市場価値の測りにくい成果を金銭に換算して評価する斬新で魅力的な方途もひらける。英国をはじめとする経済協力開発機構（OECD）諸国では、政策判断を下す重要な基準のひとつとして、費用便益分析（CBA）が用いられる。CBAは施行する政策に掛かる費用とそれがもたらす便益を金銭に換算して、社会全体におよぶ影響を評価しようとするものである。CBAではたとえば犯罪率の低下といった便益の貨幣価値は、個人が受け取った場合にそのひとの幸福の度合いに同程度の好影響をあたえる金額に相当するとして算定される。所得と犯罪率の低下がSWBにおよぼすそれぞれの影響を推定すれば、幸福に関するデータを用いても同様に評価することができる。金銭に換算された便益が政策遂行に要する費用を上回れば、政府の介入によって社会全体の幸福は増進すると推論でき、政策は実施すべきとの結論になる（快適な暮らしはどのような場合でもそれ自体が望ましいものであるとする）。

この方法は英国政府の多くの省で環境、犯罪、雇用、健康、教育、スポーツ活動などの市場と馴染まない多様な成果を評価するのに幅広く用いられている。興味深いことに、なかでも文化の分野に注目が集まったのは、文化や芸術が暮らしの向上にどのように貢献するかの評価が難しいとされてきたせいでもあるだろう。従来、これは文化施設の生む雇用や観光の経済効果によって推計されることが多かったが、そこにはわたしたちが芸術と接し、交わることに認める価値が捉えられていない。この分野の調査から、たとえば平均的な英国人は芸術公演（音楽、舞踊、演劇、映画、展覧会など）を定期的に鑑賞すると一人につき一年に935ポンド、ダンスに定期的に参加すると一年に1,671ポンド、映画館に一度行くことに8ポンドの価値を認めることがわかった。

雇用やボランティア活動、風力発電、健康と同様に、幸福関連データを用いれば人々の感じる満足度と芸術の関わりをはるかに深く評価することができる。英国の芸術が経済活動に限らず、個々の国民におよぼす便益と価値を数値化する分野でも、進歩が続いている。

幸福関連データと幸福の経済学は、21世紀の英国で生活の質の向上に役立つ大きな可能性を提供する。わたしたちは、多くの意味で、ベンサムに立ち戻ったのかもしれないが、そうすることによってより幸せな未来を手に入れたのである。

ダニエル・フジワラ｜経済学者／Simetrica創設者

[01] デレク・パーフィット著、森村進 訳『理由と人格──非人格性の倫理へ』オックスフォード、1984年（邦訳：勁草書房、1998年）

[02] 参考文献一覧は、Daniel Fujiwara/Ross Campbell, *Valuation Techniques for Social Cost-Benefit Analysis: Stated Preference, Revealed Preference and Subjective Well-Being Approaches A Discussion of the Current Issues* (Department of Works and Pensions: London, 2011) を参照のこと。

[03] Daniel Kahneman, 'Back to Bentham? Explorations of Experienced Utility', *The Quarterly Journal of Economics*, Vol. 112, No. 2, 1997, pp. 375–406

[04] Liliana Winkelmann/Rainer Winkelmann, 'Why Are the Unemployed So Unhappy? Evidence from Panel Data', *Economica*, Vol. 65, No. 257, 1998, pp. 1–15

[05] Stephan Meier/Alois Stutzer, 'Is Volunteering Rewarding in Itself?', *Economica*, Vol. 75, No. 297, 2008, pp. 39–159

[06] R. Metcalfe/Paul Dolan, 'Valuing Wind Farms: Does Experience Matter?', pauldolan.co.uk/aluing-wind-farms-doesexperience-matter.html（2014年12月8日最終閲覧）

[07] Daniel Fujiwara/Paul Dolan, 'Valuing Mental Health', 2014, psychotherapy.org.uk/UKCP_Documents/Reports/ValuingMentalHealth_web.pdf（2014年12月8日最終閲覧）

本論文は *History is Now: 7 Artists Take on Britain* (Department of Works and Pensions: London, 2011) に収録の「Happy Economics」を翻訳したものである。

Happy Economics
Daniel Fujiwara

We now know more about the people of Britain than ever before. Credit card companies, supermarkets, online businesses and websites like Google collect a vast amount of data on our everyday lives. But in Britain we also know a lot more about something much more important than our food preferences, credit ratings and holiday choices, because we collect more data than any other country on people's happiness. By happiness, I mean the broad concept of an individual's overall quality of life or their wellbeing. This wealth of data has changed the way the public, academics and government policymakers measure and understand social progress in the UK and, for British economists, this data provides a huge new opportunity to improve our understanding of how we make and assess policy.

Many philosophers and most economists take what's known as a 'welfarist' view of the world: the concept that welfare or wellbeing is central to our lives and that there is in fact nothing of greater importance than our wellbeing. Clearly we value lots of things — our health, our family, our children's education, our jobs, the environment — but they are important because ultimately they make us happy. Things like health and education are of 'instrumental value' to us (they are a means to an end), whereas wellbeing is of ultimate 'intrinsic value' (it is the end we strive for). If wellbeing is the intrinsic human good, then happiness data allows us to assess whether what we do is *right* for people and society in a moral sense; we can assess whether as individuals and governments our actions have increased people's wellbeing. And ultimately, with this data, we can make better choices for ourselves and for society.

This is not a new concept. Our interest in happiness can be traced back to the Ancient Greeks. Aristotle and Epicurus, among many others, had passionate views about what a 'good life' consisted of and how we might define happiness. After a period in which the concept of wellbeing took a backseat during the Middle Ages, it re-emerged strongly in Britain in the eighteenth century when Jeremy Bentham first attempted to build a comprehensive and systematic framework for using happiness measures in the formation of government policy. He proposed that governments should aim to maximise people's experiences of pleasure (happiness) over pain. This came to be known as utilitarianism. The inherent problem for this theory was how to measure pleasure and pain in a robust way.

Economists for the past 100 years or so have measured wellbeing in terms of the extent to which one's preferences are satisfied, based on the notion that the more of your wants that are satisfied, the better your life is.[01] This came to be known as 'utility' in economics. The concept makes measurement easier because we can use people's choices to measure their wellbeing. Subsequently, since a higher income usually means that we are able to satisfy more of our wants, income and GDP per capita metrics became, for economists, proxies for an individual's level of wellbeing. This led to the dominance of GDP and national income measures in public policy discussion in the UK over the past decades, starting, many would argue, during the Thatcher period.

But we are entering a new era. Psychologists and other social scientists have developed ways of measuring and quantifying wellbeing more directly by asking people how they feel, using what are called subjective wellbeing (SWB) questions (questions about an individual's own views about their quality of life). These SWB measures have been validated through extensive psychometric and statistical testing. Interest in SWB measures in economics and in policy making has been spurred on, to a large degree, by this new availability of data and also by a growing literature in behavioural economics (that has been driven mainly by academics in the US and UK) showing that people's preferences and their income can be poor measures of their wellbeing (more on this below). Happiness therefore is not a new concept or discipline; what is new, however, is our ability to measure happiness in a reliable way and on a large scale.

The UK is at the forefront of this global movement. In 2010, Prime Minister David Cameron launched the National Wellbeing Programme to 'start measuring our progress as a country, not just by how our economy is growing, but by how our lives are improving; not just by our standard of living, but by our quality of life.' Every year hundreds of thousands of people in Britain are asked questions about how they are feeling right now and how they feel about their life as a whole. This data is collected through national surveys and, increasingly, online and through smartphone apps. Two of the most common questions in these surveys relate to life satisfaction ('Overall, how satisfied are you with your life nowadays?') and momentary happiness ('How happy do you feel now?'), which are normally answered on scales of 0–10 or 1–7. Admittedly, there are concerns about the extent to which these short questions produce a full picture of a person's quality of life, but these measures have been shown to perform pretty well. For example, they correlate very strongly with health and suicide rates — two aspects of life that we would intuitively expect to be closely associated with wellbeing — and, in laboratory tests, the responses to these questions also correlate with activity in areas of the brain that are associated with pleasurable experiences and happiness.[02]

The appeal of this SWB data is that it is collected alongside data on a whole host of other life events and circumstances about the individual, which allows us to measure the effects of different events and circumstances on wellbeing. For example, the wellbeing literature shows that employment is good for wellbeing, social relationships are important and health is very important, while pollution and environmental degradation, political corruption and poverty are bad. And this is the big draw for economists because where we have data on policy-relevant outcomes, such as employment, health and education, we can see how these factors (which

are often the focus of high levels of public spending) impact on people's quality of life. More and more economists are using SWB measures — they even have a name: 'Happiness Economists'. And UK universities are, in many respects, leading research in this area with a high number of professional 'Happiness Economists' and a growing number of courses devoted to the subject. In the words of Nobel Laureate Daniel Kahneman, economics is going 'Back to Bentham';[03] that is to say, traditional measures such as GDP are being swapped for the more direct individual-focused measures of wellbeing that Bentham originally proposed.

Britain has a long history of thinking about wellbeing in terms of public policy. Bentham's early work was developed by later utilitarian thinkers such as John Stuart Mill, and in many respects it is fitting that the use of happiness data in policy is being led by the country that first conceptualised the approach. One could argue that the early British utilitarian thinkers helped set out the foundations for Britain becoming the world leader in developing happiness data, the importance of which seems to be recognised across the political spectrum.

There are two key roles and insights that happiness data offers for policy making. Firstly, happiness data sheds new light on what is important in our lives. We miss so much of the detail when we base all of our information on people's choices and income. For example, using a GDP view of the world, the value of employment has traditionally been measured as the gain in income experienced by the individual, and the value of volunteering to society has been calculated as the amount of money that the charity would have had to pay for the labour input had it not been provided on a voluntary basis. But UK happiness data shows that employment has a large impact on people's wellbeing over and above the benefits of receiving a wage[04] (mainly due to self-esteem, a sense of purpose, and the feeling of being a productive member of society). The data also shows that volunteers themselves see improvements in wellbeing (due to growing self-esteem and the warm-glow feeling of altruism).[05] Happiness data shows that employment and volunteering are much more important to people in Britain than we once thought.

As another example, when we just look at choices and preferences, we see, for instance, that people do not want wind farms in their local area and that they consider physical health problems to be much more serious than mental health ones. But happiness data shows that after a short period of time, wind farms in one's local area can actually lead to increases in wellbeing[06] (maybe people felt proud about caring for the environment) and that mental health conditions are far worse for wellbeing than physical health conditions.[07]
Part of what explains this is that when we ask people what they want, they underestimate the degree to which they will adapt to things; people adapt to wind farms pretty quickly and come to think they are a good thing, and people also adapt to physical health conditions much better than mental health conditions, whatever the level of severity. Happiness data allows us to look at people's actual experiences of different events and circumstances rather than what they think they want or think they will experience, which can be a notoriously poor gauge of their wellbeing.

Secondly, happiness data can be used in a very exciting new way to assign monetary values to non-market outcomes, such as improved health or lower levels of crime using the Wellbeing Valuation approach. One of the key decision-making tools in the UK — as well as other OECD countries — is cost-benefit analysis (CBA). CBA assigns monetary values to the costs and benefits of an intervention so that the overall impact on society can be assessed. According to CBA, the monetary value of a benefit, like reductions in crime, is the amount of money that, if received by the individual, would generate the same positive effect on their wellbeing as that crime reduction. This is possible to estimate from the happiness data if we estimate the impact that income and reductions in crime respectively have on SWB. If the monetised benefits outweigh the costs of the policy we can deduce that social wellbeing has increased due to the intervention and the policy should be undertaken (recall that wellbeing is the ultimate intrinsic good).

This method has been used extensively by a number of UK government departments to place a value on a range of non-market outcomes such as the environment, crime, employment, health, education, sports activities and so on. Interestingly, one area where it has received a lot of attention is in the cultural sector, because this sector has traditionally struggled to value the contribution that culture and the arts make to our lives. To date, this has often been estimated by the amount of GDP that cultural institutions generate through employing people and tourism, but clearly this traditional approach is insufficient as it does not capture the value that we place on having access to and engaging with the arts. Our research in this area has shown, for example, that on average in Britain the value of being a regular audience member of the arts (e.g. music, dance, theatre, film, exhibitions) is worth about £935 per year to the individual; regularly participating in dance is worth about £1,671 per year; and a single cinema visit about £8.

As with employment, volunteering, wind farms and health, happiness data allows us to assess the relationship between the arts and people's wellbeing at a much deeper level. We are making progress in quantifying the benefits and value that the arts in Britain have for us as individuals rather than just for the economy.

Happiness data and happiness economics offer a huge opportunity for us to improve quality of life in twenty-first century Britain. We may, in many respects, have gone back to Bentham, but in doing so we now have a happier future.

Daniel Fujiwara | Economist / Founder of Simetrica

01 Derek Parfit, *Reasons and Persons*, (Oxford University Press: Oxford, 1984)

02 For a summary of the literature see Daniel Fujiwara/Ross Campbell, *Valuation Techniques for Social Cost-Benefit Analysis: Stated Preference, Revealed Preference and Subjective Well-Being Approaches – A Discussion of the Current Issues* (Department of Works and Pensions: London, 2011)

03 Daniel Kahneman, 'Back to Bentham? Explorations of Experienced Utility', *The Quarterly Journal of Economics*, Vol. 112, No. 2, 1997, pp. 375–406

04 Liliana Winkelmann/Rainer Winkelmann, 'Why Are the Unemployed So Unhappy? Evidence from Panel Data', *Economica*, Vol. 65, No. 257, 1998, pp. 1–15

05 Stephan Meier/Alois Stutzer, 'Is Volunteering Rewarding in Itself?', *Economica*, Vol. 75, No. 297, 2008, pp. 39–159

06 R. Metcalfe/Paul Dolan, 'Valuing Wind Farms: Does Experience Matter?', available at pauldolan.co.uk/aluing-wind-farms-doesexperience-matter.html (last visited: 8 December 2014)

07 Daniel Fujiwara/Paul Dolan, 'Valuing Mental Health', 2014, available at psychotherapy.org.uk/UKCP_Documents/Reports/ValuingMentalHealth_web.pdf (last visited: 8 December 2014)

Text originally published in *History is Now: 7 Artists Take On Britain*, Hayward Publishing, 2015.

List of Works

Happy Birthday
2008

Mixed media, 40×50×40 cm

pp. 008–009
Photo:
Courtesy of the artist
Collections:
Mimi and Filiep Libeert, Private

The Museum of Incest
2008–2010

Performance, Mixed media installation, Video (35:42), Dimensions variable

Exhibition history:
Limoncello 2008, Frame Frieze Art Fair 2009, Museo de Arte Contemporaneo de Castilla y León 2010, Taipei Biennial 2012, Arnolfini 2012, Art Sonje Center 2013, Kunstverein Braunschweig 2013

p. 010
Video still:
Courtesy of the artist
Collection:
Mimi and Filiep Libeert

Impersonator
2009

Performance, Mixed media installation, Dimensions variable

Commissioned by MAK Center for Art and Architecture, Los Angeles

Exhibition history:
MAK Center for Art and Architecture 2009

pp. 012–013
Photo:
Courtesy of MAK Center for Art and Architecture

Welcome to the Hotel Munber
2009

Performance, Mixed media installation, Dimensions variable

Exhibition history:
Neue Alte Brücke 2009, Art Statements Art Basel 41 2010, Göteborgs Konsthall 2010, PinchukArtCentre 2011, The Power Plant 2011, Singapore Biennale 2011, Tate St Ives 2012, Tokyo Opera City Art Gallery 2016

pp. 013–014
Archival postcard
pp. 014–015
Installation view:
Göteborgs Konsthall
Photo:
Courtesy of Neue Alte Brücke
Collections:
Ishikawa Collection | Okayama, Prada Foundation

Feminine Endings
2009.

(with Timothy Davies) Performance, Mixed media installation, Dimensions variable

Exhibition history:
Temporäre Kunsthalle 2009, Massimo de Carlo 2009, Göteborgs Konsthall 2010, Museo Marino Marini 2010

pp. 016–017 From left:
Feminine Endings (Duet) with Timothy Davies, Two framed ink-jet C-prints, 100×100×5 cm (each)
Photo:
Courtesy of Neue Alte Brücke
Feminine Endings (with Timothy Davies) Mixed media, Dimensions variable
Photo:
Courtesy of Neue Alte Brücke
Collection:
Feminine Endings (Duet) Carla and Hugo Brown Collection

The Last Castrato
2010

Mixed media, Dimensions variable

p. 019
Photo:
Courtesy of the artist
Collection:
Private

The Mirror Stage
2009–2013

Performance, Mixed media installation, Video (27:35), Dimensions variable

Exhibition history:
Art Basel Miami Beach 2009, HAU1 Theater 2011, Performa 11 2011, San Francisco Museum of Modern Art 2011, Tate St Ives 2012, Shenzhen Sculpture Biennale 2012, Hessel Museum of Art 2012, Art Sonje Center 2013, KARST 2013, Contemporary Art Centre Vilnius 2014, Tokyo Opera City Art Gallery 2016

Video production:
Performer: Qi Bo Hofstede,
Camera & editing: Lisa Rave,
Sound: Christian Obermaier,
Lighting operator: Skye Chamberlain,
Set construction: Erik Blindermann

pp. 020–021
Performance views:
Hebbel Am Ufer, Berlin
All photos:
Marcus Lieberenz
p. 021 Right
Installation view:
SS Blue Jacket, KARST
Collections:
Ishikawa Collection | Okayama, Sammlung Verbund, Tate

Desk Job
2009

Text, Mixed media, Dimensions variable

Commissioned by OCA for The 53rd Venice Biennale, The Danish and the Nordic Pavilions 'The Collectors'

Exhibition history:
The Danish and the Nordic Pavilions Venice Biennale 2009, Galleria Civica d'Arte Moderna e Contemporanea Torino 2010

p. 022
Photo:
Anders Suneberg
Collection:
Private

Frozen
2010

Mixed media installation, Dimensions variable

Commissioned by The Cartier Award, Frieze Art Fair London 2010

Exhibition history:
Frieze Art Fair 2010, CentrePasquArt 2011, Kunstverein Braunschweig 2013

pp. 023–024
Installation view:
Kunstverein Braunschweig
Photo:
Bernd Borchardt
pp. 024–025 From left:
Installation view:
Kunstverein Braunschweig
Photo:
Bernd Borchardt
Installation view:
Centre PasquArt Biel/Bienne
Photo:
Centre PasquArt
Collection:
Prada Foundation

Imperial Tastes
2013

Mixed media, Dimensions variable

Exhibition history:
TARO NASU 2013, Parasophia 2015

pp. 026–027
Installation views:
Imperial Tastes I (Starter)
Photo:
Keizo Kioku
Courtesy of TARO NASU
Collections:
Masamichi Katayama/Wonderwall® (Starter), Seiichi Yoshino (Main), Dazaifu Tenmangu Shrine (Dessert)

The Personal Effects of Theo Grünberg
2010

Performance, Mixed media installation, Video (49:09), Dimensions variable

Supported by the Julia Stoscheck Collection, Düsseldorf

Exhibition history:
Julia Stoschek Collection 2010, São Paulo Biennial 2010, Hamburger Kunsthalle 2011

pp. 028–029
Photo:
Yun Lee
Collection:
Hamburger Kunsthalle

Phallusies

2010

Mixed media installation,
Video (14:52), Dimensions variable

Commissioned by Manifesta 8

Exhibition history:
Manifesta 8 2010, Gió Marconi 2011,
Berlinische Galerie 2011

pp. 030–031
Photo:
Courtesy of Gió Marconi and
Neue Alte Brücke

Collection:
Museum für Moderne Kunst Frankfurt

Letters from Mexico

2011

Mixed media, Dimensions variable

Exhibition history:
Proyectos Monclova 2011, Hamburger Kunsthalle 2011, San Francisco Museum of Modern Art 2011, Fondazione Bevilacqua La Masa 2013, Kunstverein Braunschweig 2013, The Carpenter Center for the Visual Arts 2014

p. 033
Gifts Returned (Reading, Believing) from the series Letters from Mexico, Mixed media, Dimensions variable
Photo:
Courtesy of Dvir Gallery

Collections:
The Baloise Collection, Hamburger Kunsthalle, Private

Not A Thief's Journal

2013

Mixed media, Dimensions variable

p. 034
Photos:
Keizo Kioku
Courtesy of TARO NASU

Collection:
Private

Artists' Book Club: Hakuruberri Fuin no Monogatari

2010

Mixed media, Dimensions variable,
Video (26:20)

Commissioned by CCA Wattis Institute for Contemporary Arts

Exhibition history:
CCA Wattis Institute for Contemporary Arts 2010, Iniva 2011, The Museum of Modern Art New York 2012, Okayama Art Project 2014

Video production:
Performer: Phineas Pett,
Camera editing: Chris Whittingham

p. 035
Imagineering Okayama Art Project
Courtesy of imagineering Production Committee, Neue Alte Brücke,
Gió Marconi and TARO NASU
Photo:
Hiroyasu Matsuo

p. 036
Video still:
Courtesy of the artist

Collections:
Carla and Hugo Brown Collection,
Ishikawa Collection | Okayama,
Nerio and Marina Fossatti Collection,
Private

Rehearsal for a Reunion

2011–2013

Mixed media installation, Video (14:18), Dimensions variable

Commisioned by
Tate and Museum of Contemporary Art Tokyo

Exhibition history:
Museum of Contemporary Art Tokyo 2011, Tate St Ives 2012, Dvir Gallery 2012, Gwangju Biennale 2012,
École des Beaux-Arts 2013, Carpenter Center for the Visual Arts 2014,
Solomon R. Guggenheim Museum 2015, Dojima River Biennale 2015,
Tokyo Opera City Art Gallery 2016

Video production:
Performer: Robin Arthur,
Camera: Lisa Rave & Erik Blindermann,
Editing: Lisa Rave & Daniel Horn,
Sound: Christian Obermaier,
Assistant: Skye Chamberlain

p. 037
Photo:
Courtesy of Dvir Gallery

pp. 037–038
Video still:
Courtesy of the artist

pp. 038–039
Installation view:
Solomon R. Guggenheim Museum
Photo:
David M. Heald

Collections:
Fondation Lafayette, The Guggenheim Collection, Ishikawa Collection | Okayama

Future/Perfect

2012

Performance, Mixed media installation, Dimensions variable

Exhibition history:
Manchester Art Gallery 2011,
Ruhr Triennale 2012, Kaldor Public Art Projects 2013, Kunstverein Braunschweig 2013, Museum of Contemporary Art Roskilde 2014

pp. 040–042
Installation views:
'13 Rooms' at Pier 2/3 Sydney
Photos:
Jamie North/Kaldor Public Art Projects

Rebekkah

2012

Mixed media, Video (07:23),
Dimensions variable

Exhibition history:
Shanghai Biennale 2012, Kunstverein Braunschweig 2013, Contemporary Art Society 2014, Leeds Art Gallery 2014, Okayama Art Project 2014, Tokyo Opera City Art Gallery 2016

Video production:
Narrator: Maria Bartau Madariaga,
Editing: Moritz Fehr,
Sound: Christian Obermaier

pp. 043–044
Video still:
Courtesy of the artist

pp. 044–046
Production photos:
Courtesy of the artist

pp. 047–048
Installation views:
Contemporary Art Society London
Photo:
Joe Plommer

pp. 049–050
Installation view:
Leeds Art Gallery
Photo:
Jerry Hardman-Jones

p. 050 Right
Installation view:
Contemporary Art Society London
Photo:
Joe Plommer

Collections:
Fondation Francès, Ishikawa Collection | Okayama, Leeds Art Gallery, Sammlung Philara

Studio Pietà

2013

Mixed media installation,
Video (20:30), Dimensions variable

Commissioned by
Sharjah Art Foundation, SB11 2013

Exhibition history:
Sharjah Biennial 2013, Andrea Rosen Gallery 2013, Kunstverein Braunschweig 2013, Carpenter Center 2014,
Centre Photographique d'Ile-de-France 2014, Parasophia 2015

Video production:
Performers: Lisa Oettinghaus & David A. Hamade,
DOP & editing: Moritz Fehr,
2nd camera: Nicola Hens,
Line producer & research: Lisa Rave,
Photographer: Rainer Elstermann,
Set technician: Thomas & Rene Rapedius,
Hair & make up: Jula Hoepfer,
Assistants: Alex Turgeon & Jean-Marc Routhier

p. 053
Photo:
Courtesy of the artist

pp. 054–058
Video stills:
Courtesy of the artist

pp. 058–060
Installation views:
Andrea Rosen Gallery
Photo:
Lance Brewer

p. 060 Right
Archival photo:
Courtesy of the artist

pp. 061–062
Installation views:
Andrea Rosen Gallery
Photo:
Lance Brewer

Collections:
Museum of Contemporary Art Krakow,
The Museum of Modern Art New York,
Sharjah Art Foundation

Toolz I

2013

Bronze, Apple mouse,
12 × 4.5 × 7 cm

Commissioned by
Kunstverein Braunschweig

Exhibition history:
Kunstverein Braunschweig 2013,
Tokyo Opera City Art Gallery 2016

p. 064
Photo:
Courtesy of the artist

Collection:
Private

The Problem of the Rock

2013

Performance, Mixed media
installation, Dimensions variable

Exhibition history:
Dazaifu Tenmangu Shrine 2013,
Mori Art Museum 2013

pp. 065–066
Archival photo:
Courtesy of the artist

pp. 067–076
Procession photos:
Dazaifu Tenmangu Shrine
Photos:
Sakiho Sakai (ALBUS),
Junko Nakata (ALBUS)

Collection:
Dazaifu Tenmangu Shrine

Echo Tower

2014

Mixed media, Dimensions variable

Exhibition history:
Odense Sculpture Triennial 2014,
Tokyo Opera City Art Gallery 2016

pp. 078–079
Photo:
Courtesy of the artist

Collection:
Private

New Pompidou

2014

Mixed media installation, Video
(19:25)

Commissioned by
Fondation d'entreprise Galeries
Lafayette and conceived for the
Centre Pompidou

Exhibition history:
Fondation d'entreprise Galeries
Lafayette 2014, Centre Pompidou 2014

Video production:
Narrator: Bernard Blistène,
Camera: Xiao-Xing Cheng,
Editing: Moritz Fehr,
Assistants: Yan Tomaszewski & Maria
Bartau Madariaga

p. 081
Archival photo

pp. 082–086
Performance and procession
photos: Nicolas Giraud
Courtesy of Fondation d'entreprise
Galeries Lafayette

pp. 086–088
Installation views:
Courtesy of the Centre Pompidou

Collection:
Fondation Lafayette

Fabulous Beasts

2015–

Shaved fur coats on wooden
stretchers, Dimensions variable

Exhibition history:
Proyectos Monclova 2015, Dvir Gallery
2015, Marian Goodman Gallery 2015,
British Art Show 8 2015, Laura Bartlett
Gallery 2015, Tokyo Opera City Art
Gallery 2016

pp. 089–092
Production photos:
Courtesy of the artist

pp. 092–093 From left:
Bleeding Ocelot
130 × 77 × 3 cm
Photo:
Courtesy of Dvir Gallery
Ocelot
130 × 85 × 3.2 cm
Photo:
Courtesy of Proyectos Monclova
Wild Cat
127 × 174 cm
Photo:
Courtesy of Proyectos Monclova
Excellent Mink
130.2 × 85 × 3.2 cm
Photo:
Courtesy of Proyectos Monclova
Stripy Fox
130 × 85 × 3.2 cm
Photo:
Courtesy of Proyectos Monclova

pp. 093–094 From right:
Antique Wild Cat
115 × 85 × 3 cm
Photo:
Courtesy of Dvir Gallery
Blue Night Ocelot
115 × 85 × 3 cm
Photo:
Courtesy of Dvir Gallery
Thorer Process Mink
80 × 75 × 2 cm
Photo:
Courtesy of Marian Goodman Gallery

Collection:
Private

Masks (Merkel)

2015–

Make-up on canvas, Dimensions
variable

Exhibition history:
Proyectos Monclova 2015, Dvir Gallery
2015, Marian Goodman Gallery 2015,
Kunsthalle Lingen 2015, Tokyo Opera
City Art Gallery 2016

pp. 095–096
Archival photo

pp. 096–097
Masks (Merkel D7.1),
Make-up on canvas,
96 × 206 × 6.5 cm
Photo:
Courtesy of Marian Goodman Gallery

pp. 097–100 From right:
Masks (Merkel HI6.1),
Make-up on canvas,
206 × 166 × 6.5 cm
Photo:
Courtesy of Marian Goodman Gallery
Masks (Merkel HI6.1),
Make-up on canvas,
206 × 166 × 6.5 cm
Photo:
Courtesy of Marian Goodman Gallery
Masks (Merkel A7.1),
Make-up on canvas,
186 × 56 × 5.5 cm
Photo:
Courtesy of Marian Goodman Gallery
Archival photo:
Courtesy of the artist
Masks (Merkel E2.1),
Make-up on canvas,
76 × 66.5 × 5.5 cm
Photo:
Courtesy of Marian Goodman Gallery
Masks (Merkel D7.1),
Make-up on canvas,
96 × 206 × 6.5 cm
Photo:
Courtesy of Marian Goodman Gallery

pp. 100–101
Installation view:
Dvir Gallery
Photo:
Courtesy of Dvir Gallery

Collections:
Ardalan Collection, Private

Ich

2015–

Mixed media with bronze patina,
Dimensions variable

Exhibition history:
Proyectos Monclova 2015, Dvir Gallery
2015, ICASTICA 2015, Sandy Brown
2015, Tokyo Opera City Art Gallery 2016

pp. 101–105 From right:
Ich (2 × 9 L 1 × 18 L Trenta 5 Trennsystem)
Photo:
Courtesy of Proyectos Monclova
Ich (2 × 7 L Tandem 7 Trennsystem)
Photo:
Courtesy of Proyectos Monclova
Ich (2 × 15 L Rondo Trennsystem)
Photo:
Courtesy of Proyectos Monclova
Ich (3 × 10 L Multi-Box Trennsystem)
Photo:
Courtesy of Proyectos Monclova
Ich (2 × 7 L 2-fach Trennsystem)
Photo:
Courtesy of Proyectos Monclova

pp. 105–106
Installation view:
Courtesy of Proyectos Monclova
Photo:
Courtesy of Proyectos Monclova

Collection:
Private

Hello

2015

Video (10:16)

Exhibition history:
Proyectos Monclova 2015, Lincoln Center (screening) 2015, British Art Show 8 2015, Tokyo Opera City Art Gallery 2016

Video production:
Performers: Maria Martinez & Max Baberg,
DOP & editing: Moritz Fehr,
CGI: Max Baberg,
Lighting: Ágnes Pákozdi,
Sound: Benjamin Kalisch,
Assistants: Yan Tomaszewski & Maria Bartau Madariaga

pp. 107–114

Video stills:
Courtesy of the artist

History is Now: 7 Artists Take on Britain

2015

Hayward Gallery

pp. 115–116

Archival photo:
Courtesy of the artist

pp. 116–121

Installation views of
Simon Fujiwara's curated section at Hayward Gallery, History is Now:
7 Artists Take on Britain
Photos:
Linda Nylind

pp. 121–122

Archival photo

pp. 122 Right

Installation view of Simon Fujiwara's curated section at Hayward Gallery, History is Now: 7 Artists Take on Britain
Photo:
Linda Nylind

Modern Marriage

2015

Epoxy marble resin, Bronze, Gold, Dimensions variable

pp. 123–124

Archival photo

p. 124 Center

Photo: Courtesy of the artist

pp. 124–125

Photo:
Courtesy of Embassy Gardens by Ecoworld Ballymore

pp. 125–126

Archival photo

Pavilion for a Mask

2014

Mixed media, Dimensions variable

Exhibition history:
Tokyo Opera City Art Gallery 2016

pp. 127–128

Photo:
MMB Tillman Burgert

pp. 128–129

Photos:
Courtesy of Dvir Gallery

Lactose Intolerance

2015

Acrylic or Oil on canvas, Dimensions variable

Exhibition history:
Dvir Gallery 2015, Tokyo Opera City Art Gallery 2016

p. 130

Archival photo:
Courtesy of the artist

pp. 131–133 From right:
Lactose Intolerance (Nostalgic Style)
63.5 × 54.5 × 5 cm
Photo:
Courtesy of Dvir Gallery
Lactose Intolerance (Comic Style)
95 × 75 × 5 cm,
95 × 75 × 5 cm,
95 × 74 × 5 cm
Photo:
Courtesy of Dvir Gallery

p. 134

Installation view:
Dvir Gallery
Photo:
Courtesy of Dvir Gallery

p. 135

Detail, Lactose Intolerance (Hyperrealist Style)
124.5 × 280 × 5 cm
Photo:
Courtesy of Dvir Gallery

pp. 135–136

Lactose Intolerance (Hyperrealist Style)
124.5 × 280 × 5 cm
Photo:
Courtesy of Dvir Gallery

Collection:
Private

No Milk Today

2015

Cow manure on canvas,
53.5 × 43.5 × 3 cm (each)

Exhibition history:
Dvir Gallery 2015

pp. 137–138

Production photo:
Courtesy of the artist

pp. 138–142

No Milk Today series
photos:
Courtesy of Dvir Gallery

pp. 142–143

Installation view:
Courtesy of Dvir Gallery

Collection:
Private

Book

2014

Mixed media, Video (Looped)

pp. 144–145

Photo:
Courtesy of the artist

The Way

2015

Six digital C-prints on archival photo paper, 120 × 240 cm (each)

Exhibition history:
Parasophia 2015, yu-un Obayashi Collection 2016

p. 146

Archival photo

pp. 147–150

Photos:
Courtesy of the artist

Collection:
Obayashi Collection

Exhibitions in the inventory are selected.

Exhibition History

Solo Exhibitions

2016

'White Day'
Tokyo Opera City Art Gallery, Tokyo
Curator: Shino Nomura

Exhibited works:
multiple works 2008–2016, in a site-specific installation

[Catalogue]

'Pearl Diving'
TARO NASU, Tokyo

Exhibited work:
Cultured Pearls 2016

'The Way'
yu-un, Obayashi Collection, Tokyo

Exhibited work:
The Way 2015, in a site-specific installation

2015

Modern Marriage
Public art sculpture (permanent) adjacent to the new American Embassy, London
Curator: Norman Rosenthal

A Spire
Public art sculpture (permanent) for the University of Leeds, Leeds
Curator: Layla Bloom

'Lactose Intolerance'
Dvir Gallery, Tel Aviv

Exhibited works:
Lactose Intolerance, *No Milk Today*, *Masks (Merkel)*, *Ich*
all works 2015

'Peoples of the Evening Land'
Proyectos Monclova, Mexico City

Exhibited works:
Hello (projection), *Fabulous Beasts*, *Masks (Merkel)*, *Ich*
all works 2015

2014

'Three Easy Pieces'
Carpenter Center for the Visual Arts, Harvard University, Cambridge
Curator: James Voorhies

Exhibited works:
Letters from Mexico 2011, *Rehearsal for a Reunion* 2011, *Studio Pietà* 2013

[Catalogue]

'Rebekkah'
Contemporary Art Society, London

Exhibited work:
Rebekkah 2012

2013

'Grand Tour'
Kunstverein Braunschweig, Braunschweig
Curator: Hilke Wagner

Exhibited works:
The Museum of Incest 2008, *Letters from Mexico* 2011, *Rebekkah* 2012, *Frozen* 2010, *Future/Perfect* 2012, *Studio Pietà* 2013

'Studio Pietà (King Kong Komplex)'
Andrea Rosen Gallery, New York

Exhibited work:
Studio Pietà 2013

'Aphrodisiac Foundations (Imperial Hotel 1968, King Kong Komplex)'
TARO NASU, Tokyo

Exhibited works:
Imperial Tastes I-III, *Dawn on the Imperial Suite*, *Welcome to the Imperial Bar. The Year is 1968, the Time is 8 O'clock, the Drink is Mount Fuji. Please Enjoy Because Soon This Will All Be Gone....*, *Imperial Tastes (fragments)1-3*
all works 2013

'The Problem of the Rock'
Dazaifu Tenmangu Shrine, Fukuoka
Curator: Eri Anderson

Exhibited work:
The Problem of the Rock (performance procession) 2013
Commissioned by Dazaifu Tenmangu Art Program

[Catalogue]

'Simon Fujiwara'
Art Sonje Center, Seoul
Curator: Sunjung Kim

Exhibited works:
The Museum of Incest 2008, *The Mirror Stage* 2009, *Rehearsal for a Reunion* 2011

2012

'Rehearsal for a Reunion (with the Father of Pottery)'
Dvir Gallery, Tel Aviv

Exhibited work:
Rehearsal for a Reunion 2011

'The Museum of Incest'
Crawford Art Gallery, Cork
Curator: Rachel Thomas

Exhibited work:
The Museum of Incest 2008

[Catalogue]

'Since 1982'
Tate St Ives, St Ives
Curators: Martin Clarke, Miguel Amado

Exhibited works:
Autobiography of a Museum, *Saint Simon*, *Selective Memory*, *Mothers of Invention* all works 2012, *Rehearsal for a Reunion*, *Letters from Mexico* both works 2011, *Welcome to the Hotel Munber* 2009, *The Mirror Stage* 2009,
With works by;
Alfred Wallis, Barbara Hepworth, Sarah Lucas, Bernard Leach, Patrick Heron, Mona Hatoum, Francis Bacon, Shoji Hamada, Janet Leach

[Catalogue]

2011

'The Boy Who Cried Wolf'
Touring theatre performance:
HAU1 Theater, Berlin;
Performa 11, New York;
San Francisco Museum of Modern Art, San Francisco
Curators: Matthias Lillienthal, Roselee Goldberg, Frank Smigiel

Staged works:
The Mirror Stage 2009, *Welcome to the Hotel Munber* 2009, *The Personal Effects of Theo Grünberg* 2010

'Welcome to the Hotel Munber'
The Power Plant, Toronto
Curator: Melanie O'Brian

Exhibited work:
Welcome to the Hotel Munber 2009

'Phallusies'
Gió Marconi, Milano

Exhibited work:
Phallusies 2010

'Letters From Mexico'
Proyectos Monclova, Mexico City

Exhibited work:
Letters from Mexico 2011

2010

'The Personal Effects of Theo Grünberg'
Julia Stoschek Collection, Düsseldorf
Curator: Philipp Fürnkäs

Exhibited work:
The Personal Effects of Theo Grünberg (installation and performance) 2010

'Welcome to the Hotel Munber'
Art Statements Art Basel 41, Basel

Exhibited work:
Welcome to the Hotel Munber 2009

'Frozen'
Frieze Art Fair, London

Exhibited work:
Frozen 2010
Exhibition commission for Cartier Award, 2010

2009

'Welcome to the Hotel Munber'
Neue Alte Brücke, Frankfurt am Main

Exhibited work:
Welcome to the Hotel Munber (performance) 2009

'The Museum of Incest'
Frame, Frieze Art Fair, London

Exhibited work:
The Museum of Incest 2008

'Impersonator'
Schindler House / MAK Center for Art and Architecture, Los Angeles

Exhibited work:
Impersonator (one night performance) 2009

Group Exhibitions and Performances [Selection]

2015

'British Art Show 8'
Leeds Art Gallery, Leeds
Curators: Anna Colin, Lydia Yee

Exhibited works:
Hello, Fabulous Beasts both works 2015

'HyperLocal: Major Discoveries—13th Contemporary Art in the Traditional Museum Festival'
St. Petersburg
Curator: Alisa Prudnikova

Exhibited work:
Fabulous Beasts 2015

'Storylines—Contemporary Art at the Guggenheim'
Solomon R. Guggenheim Museum, New York
Curators: Katherine Brinson, Carmen Hermo, Nancy Spector, Nat Trotman, Joan Young

Exhibited work:
Rehearsal for a Reunion 2011

'J'adore'
Kunsthalle Lingen, Lingen
Curator: Meike Behm

Exhibited work:
Masks (Merkel) 2015

'Presque rien'
Marian Goodman Gallery, Paris

Exhibited work:
Masks (Merkel) 2015

'Parasophia—Kyoto International Festival of Contemporary Culture'
Kyoto
Curator: Shinji Kohmoto

Exhibited works:
Studio Pietà 2013, *Imperial Tastes* 2013, *The Way* 2015

[Catalogue]

'History is Now—7 Artists Take on Britain'
Hayward Gallery, London
Curator: Cliff Lauson

Exhibited works:
Curatorial project with artists' selection of objects, costumes and artworks by artists including Sam Taylor-Johnson, Prem Sahib, David Hockney, Ryan Gander, Anish Kapoor, Ceal Floyer, Gavin Turk, Matthew Derbyshire and Pablo Bronstein

[Catalogue]

2014

'The Other Sight'
Contemporary Art Centre, Vilnius
Curator: Julia Cistiakova

Exhibited work:
The Mirror Stage (sculpture version) 2014

'Imagineering'
Okayama Art Project, Okayama

Exhibited works:
Rebekkah 2012, *Artists' Book Club: Hakuruberri Fuin no Monogatari* 2010, *Art Worlds (Mex in the City)* 2013

'Un Nouveau Festival'
Centre Pompidou, Paris
Curator: Bernard Blistène

Exhibited work:
New Pompidou 2014
Commissioned by Fondation d'entreprise Galeries Lafayette

'Still Waters Run Deep—Odense Sculpture Triennial 14'
Odense
Curator: Charlotte Sprogøe

Exhibited work:
Echo Tower 2014

'Narrating Objects: Unlocking the Stories of Sculpture'
Leeds Art Gallery, Leeds
Curator: Sophie Raikes

Exhibited work:
Rebekkah 2012

2013

'Museum Off Museum'
Kunstverein Bielefeld, Bielefeld
Curator: Thomas Thiel

Exhibited work:
Rehearsal for a Reunion 2011

'Roppongi Crossing 2013'
Mori Art Museum, Tokyo
Curators: Mami Kataoka, Reuben Keehan, Gabriel Ritter

Exhibited work:
The Problem of the Rock 2013

[Catalogue]

'13 rooms: Kaldor Public Art Project #27'
Pier 2/3, Sydney
Curators: Hans Ulrich Obrist, Klaus Biesenbach

Exhibited work:
Future/Perfect 2012

'I Know You'
Irish Museum of Modern Art, Dublin
Curators: Rachel Thomas, Nicholas Hirsh, Tobias Rehberger

Exhibited work:
Letters from Mexico 2011

[Catalogue]

'Sharjah Biennial 11'
Sharjah
Curator: Yuko Hasegawa

Exhibited work:
Studio Pietà 2013

[Catalogue]

'When Attitudes Became Form Become Attitudes'
The Museum of Contemporary Art, Detroit (2013), CCA Wattis Institute for Contemporary Arts, San Francisco (2012)
Curator: Jens Hoffman

Exhibited work:
Art Worlds (Mex in the City) 2013

2012

'Roundtable: The 9th Gwangju Biennale'
Gwangju
Curators: Nancy Adajania, Wassan Al-Khudhairi, Mami Kataoka, Carol Yinghua Lu, Alia Swastika

Exhibited work:
Rehearsal for a Reunion 2011

[Catalogue]

'Modern Monsters/Death and Life of Fiction: Taipei Biennial 2012'
Taipei
Curator: Anselm Franke

Exhibited work
The Museum of Incest 2008

[Catalogue]

'Reactivation: The 9th Shanghai Biennale'
Shanghai
Curators: Qiu Zhijie, Boris Groys, Jens Hoffmann, Johnson Chang

Exhibited work:
Studio Pietà 2013

[Catalogue]

'12 Rooms: Ruhr Triennale'
Essen
Curators: Klaus Biesenbach, Hans Ulrich Obrist

Exhibited work:
Future/Perfect 2012

'7th Shenzhen Sculpture Biennale'
Shenzhen
Curators: Liu Ding, Carol Yinghua Lu, Su Wei

Exhibited work:
The Mirror Stage 2009

[Catalogue]

'Made In Germany Zwei'
Kunstverein Hannover, Hannover
Curators: Susanne Figner, Martin Germann, Antonia Lotz, Kathrin Meyer, Carina Plath, Gabriele Sand, Kristin Schrader, Ute Stuffer, René Zechlin

Exhibited work:
The Personal Effects of Theo Grünberg 2010

[Catalogue]

'Duplicitous Storytellers'
Casa Del Lago, Mexico City
Curator: Fabiola Iza

Exhibited work:
Rehearsal for a Reunion 2011

[Catalogue]

'These are not obligations but I want to (a response in two parts)'
Center for Curatorial Studies, Bard College, New York
Curator: Suzie Halajian

Exhibited work:
The Mirror Stage (video) 2009

'Print/Out'
The Museum of Modern Art, New York
Curators: Christophe Cherix, Kim Conaty

Exhibited work:
Artists' Book Club: Hakuruberri Fuin no Monogatari 2010

[Catalogue]

2011

'The Air We Breathe'
San Francisco Museum of Modern Art, San Francisco
Curator: Apsara DiQuinzio

Exhibited work:
Letters from Mexico 2011

[Catalogue]

'The Museum Show Part 2'
Arnolfini, Bristol
Curator: Nav Haq

Exhibited work:
The Museum of Incest 2008

[Catalogue]

'Berlin 2000-2011 Playing Among the Ruins'
Museum of Contemporary Art Tokyo, Tokyo
Curators: Yuko Hasegawa, Angela Rosenberg

Exhibited work:
Rehearsal for a Reunion 2011

[Catalogue]

'Arkhaiologia'
CentrePasquArt, Biel/Bienne

Exhibited work:
Frozen 2010

[Catalogue]

'Based in Berlin'
Berlin
Curator: Magdalena Magiera

Exhibited work:
Phallusies 2010

[Catalogue]

'11 Rooms: Manchester International Festival'
Manchester
Curators: Hans Ulrich Obrist, Klaus Biesenbach

Exhibited work:
Playing the Martyr 2011

'Archive und Geschichte(n)'
Hamburger Kunsthalle, Hamburg
Curator: Petra Kluver

Exhibited works:
The Personal Effects of Theo Grünberg 2010, *Letters from Mexico* 2011

'Palace Party'
Charlottenborg Kunsthal, Copenhagen
Curator: Rhea Dall

Exhibited work:
The Personal Effects of Theo Grünberg (performance) 2011

2010

'There is Always a Cup of Sea to Sail In: 29th São Paulo Biennial'
São Paulo
Curators: Moacir dos Anjos, Agnaldo Farias

Exhibited work:
The Personal Effects of Theo Grünberg 2010

[Catalogue]

'A Performance Project'
Kunsthaus Bregenz Arena, Bregenz
Curators: Eva Birkenstock, Joerg Franzbecker

Exhibited work:
The Museum of Incest (performance) 2008

'Huckleberry Finn'
CCA Wattis Institute for Contemporary Arts, San Francisco
Curator: Jens Hoffman

Exhibited work:
Artists' Book Club: Hakuruberri Fuin no Monogatari 2010

[Catalogue]

Manifesta 8
Murcia
Curators: Alexandria Contemporary Arts Forum [Only ACAF were curators for my work]

Exhibited work:
Phallusies 2010

[Catalogue]

'Disidentification'
Göteborgs Konsthallen, Göteborg

Exhibited work:
Welcome to the Hotel Munber 2009

[Catalogue]

'Educando el saber'
Museo de Arte Contemporaneo de Castilla y León, León
Curator: Octavio Zaya

Exhibited work:
The Museum of Incest 2008

'All the Memory in the World'
Galleria Civica d'Arte Moderna e Contemporanea, Torino
Curator: Elena Volpato

Exhibited works:
multiple works 2009–2010

[Catalogue]

2009

'The Collectors: The Danish and the Nordic Pavilions — 53rd Venice Biennale'
Venezia
Curators: Elmgreen & Dragset

Exhibited work:
Desk Job 2009

'Scorpio's Garden' (with Tim Davies)
Temporäre Kunsthalle, Berlin
Curator: Kirstine Roepstoff

Exhibited work:
Feminine Endings (performance) 2009

[Catalogue]

'Art Perform—Art Basel Miami Beach'
Miami Beach
Curator: Jens Hoffmann

Exhibited work:
The Mirror Stage (performance) 2009

'Friends of The Divided Mind'
Royal College of Art, London

Exhibited work:
The Musuem of Incest 2008

[Catalogue]

Exhibitions in the inventory are selected.

本書は下記の展覧会に際して
出版されました

サイモン・フジワラ
ホワイトデー

東京オペラシティ アートギャラリー
2016年1月16日[土]— 3月27日[日]

主催
公益財団法人 東京オペラシティ文化財団

協賛
日本生命保険相互会社

助成
芸術文化振興基金、ifa

協力
TARO NASU

This publication is published in
conjunction with the following exhibition.

Simon Fujiwara
White Day

Tokyo Opera City Art Gallery
Saturday, 16 January – Sunday, 27 March, 2016

Organiser:
Tokyo Opera City Cultural Foundation

Sponsor:
Nippon Life Insurance Company

Grants from:
Japan Arts Fund, ifa

Cooperation:
TARO NASU

Catalogue, Simon Fujiwara (2016)

構成・執筆 サイモン・フジワラ	Composition and text by Simon Fujiwara
デザイン 森大志郎	Design by Daishiro Mori
編集 中村水絵 [HeHe] 野村しのぶ [東京オペラシティ アートギャラリー] マリア・バルタウ・マダリアガ [スタジオ・サイモン・フジワラ]	Edited by Mizue Nakamura [HeHe] Shino Nomura [Tokyo Opera City Art Gallery] Maria Bartau Madariaga [Studio Simon Fujiwara]
写真 ベネディクテ・ギルデンスターン・セーヘステッド プリント・アシスタント クリスティーナ＝タリサ・ジャガード	Plate photography by Benedicte Gyldenstierne Sehested Printing assistant Kristina-Talisa Jaggard
執筆 野村しのぶ クリストファー・グレイゼック ダニエル・フジワラ	Texts by Shino Nomura Christopher Glazek Daniel Fujiwara
翻訳 野村しのぶ \| pp.154–159, 161–166 奥村雄樹 \| pp. 159–161 字幕原稿を改訂 ミラー和空 \| pp.184–185 木下哲夫 \| pp.186–187, 190–191	Translated by Shino Nomura \| pp.154–159, 161–166 Yuki Okumura \| pp. 159–161, edited version of subtitle Waku Miller \| pp.184–185 Tetsuo Kinoshita \| pp.186–187, 190–191
英文校閲 エイミー・オンティヴェロス 増田知香 リンゼイ・ウェストブルック	English proofreading by Amy Ontiveros Chika Masuda Lindsey Westbrook
発行日 2016年1月16日 第1刷	First published in Japan, January 2016
発行者 中村水絵	Publisher Mizue Nakamura
発行所 HeHe (ヒヒ) 〒150-0022 東京都渋谷区恵比寿南3-3-11 パラシオン恵比寿1101 Tel & Fax 03-6303-4042 info@hehepress.com www.hehepress.com	Published by HeHe 3-3-11 #1101 Ebisu-minami, Shibuya-ku, Tokyo 150-0022 Japan Tel & Fax: +81(0)3-6303-4042 info@hehepress.com www.hehepress.com
乱丁・落丁本は送料小社負担にて お取り替えいたします。 本書の無断複写・複製・引用及び 構成順序を損ねる無断使用を禁じます。	All rights reserved.
印刷・製本 株式会社ライブアートブックス	Printed and bound in Japan by Live Art Books
Printed in Japan	ISBN 978-4-908062-16-2 C0070

Text credits:
© Simon Fujiwara
© Shino Nomura
© Christopher Glazek
© Daniel Fujiwara

The courtesy and copyrights of the
respective organisations, individuals and
the photographer are credited as listed.

The publisher has made every effort to
contact all copyright holders. If proper
acknowledgement has not been made,
we ask copyright holders to contact the
publisher. All works are © the artist
unless otherwise stated.

© 2016 Simon Fujiwara
© 2016 HeHe